THE PEAR TREE
Is Torture Ever Justified?

THE PEAR TREE
Is Torture Ever Justified?

by

Eric Stener Carlson

CLARITY PRESS, INC.

© 2006 Eric Stener Carlson

ISBN: 0-932863-45-0

In-house editor: Diana G. Collier

Cover photo by George Robins/The Stock Solution

ALL RIGHTS RESERVED: Except for purposes of review, this book may not be copied, or stored in any information retrieval system, in whole or in part, without permission in writing from the publishers.

Also by Eric Stener Carlson:

I Remember Julia: Voices of the Disappeared (Temple University Press)

Library of Congress Cataloging-in-Publication Data

Carlson, Eric Stener.
 The pear tree : is torture ever justified? / by Eric Stener Carlson ; foreword by Richard Pierre Claude.
 p. cm.
 ISBN 0-932863-45-0
1. Torture—Philosophy. 2. Carlson, Eric Stener. 3. Human rights workers—Biography. 4. Human rights. 5. Political violence. I. Title: Is torture ever justified?. II. Title.
 HV8593.C35 2006
 363.2'32—dc22
 2005028361

CLARITY PRESS, INC.
Ste. 469, 3277 Roswell Rd. N.E.
Atlanta, GA. 30305

http://www.claritypress.com

I dedicate this book to my wife, Luján, and to my son, Eric James. I promise to do anything to protect them from harm, anything except that one thing. May God help me.

Table of Contents

Foreword by Richard Pierre Claude		13
Author's Introduction		15
Chapter One:	Insomnia	19
Chapter Two:	The Garden	23
Chapter Three:	The Stranger	25
Chapter Four:	The Millstone	28
Chapter Five:	The Fortress	33
Chapter Six:	Of Love and Whores	36
Chapter Seven:	Literary Deconstruction	41
Chapter Eight:	Self-Defense	44
Chapter Nine:	Thirst	47
Chapter Ten:	The Petting Zoo	49
Chapter Eleven:	Elocution	54
Chapter Twelve:	Primary Sources	58
Chapter Thirteen:	My Mother's Gloves	63
Chapter Fourteen:	Strays	66
Chapter Fifteen:	Ramón Screams	69
Chapter Sixteen:	Belief System	73
Chapter Seventeen:	Hemingway's Shotgun	77
Chapter Eighteen:	Lunch among Equals	82
Chapter Nineteen:	Behind the Curtain	88
Chapter Twenty:	The Pear Tree	93
Epilogue		95
Endnotes		99

Foreword

Eric Stener Carlson's partly autobiographical work introduces the reader to the field of human rights without legal jargon and philosophical abstractions. Instead he begins by recounting troubled childhood memories of a friend's abuse first seen through juvenile eyes, later brought by "maturity" to the "logic of the persecutor", and finally sleepless adult nights unsettled by the "need to find out if anything is still holy for me."

The Pear Tree is an extended answer to that question. At one level, the book is a highly personal examination of conscience. It is also an account of the author's journey through the credentialing processes of a young professional becoming a human rights activist, forensic investigator, and analyst of the records of detritus of cruelty and mass slaughter authorized by craven authorities in the recent Balkans wars. Like past evil regimes in Argentina, Cambodia and elsewhere, they justified the taking of one life to save another, excusing torture to right wrongs. The delusions embedded in these exaltations of bestiality are finally brought to the doorsteps of United States officials cravenly deflecting blame for their thoughtless public policy by merely impaneling low level investigations of underlings engaged in torture of detainees at Abu Ghraib and Guantanamo Bay.

This is a unique work of spiritual exorcism that both exposes the errors of excuses offered for torture while allowing us to see those who harm us as human. Moreover, it is a work of narrative philosophy that is purgative in intent, and a work of high literary merit that is ultimately healing in effect.

Richard Pierre Claude
Founding Editor, *Human Rights Quarterly* (USA)
Editorial Board Member, SUR,
International Journal of Human Rights
(Sao Paulo)

THE PEAR TREE
Is Torture Ever Justified?

While the events described in this book are true, certain names, dates, locations and details have been modified in order to respect the privacy of the individuals involved. All opinions herein are those of the author alone, and do not necessarily represent the positions and policies of any organization for which he has worked or currently works.

Introduction

The following is a personal account of torture. I am, however, neither the torturer, nor the torture victim. I am, instead, the observer—the witness once removed—a role assumed by international human rights advocates such as myself. In the following pages, I explore the personal decision to use torture to save my child, your child. In doing so, I draw upon my childhood fears, my experience as an advocate, my hopes as a father.

But this personal story is framed by a larger context. It is not just a matter of whether I, or some other father or mother—from the United States or Australia, the former Yugoslavia or Peru—makes the individual decision to use torture against someone who threatens the well-being of his or her child. Surrounding, swirling around that choice, like dead leaves in autumn, are ideologies, politics, power structures.

We civilians are usually not the ones who commit torture. Rather, driven by the fear that our children may be harmed by what I call "The Stranger"—call him rapist, terrorist or revolutionary—we authorize our soldiers and police to do whatever they can to protect them, to protect us. Sometimes this authorization is tacit, and, as long as the State achieves results, we—people from all walks of life, under democracy or dictatorship—turn a blind eye. Sometimes this authorization is explicit, and we demand that they extract an eye for an eye. Either way, our leaders often fan this fear in us, and they capitalize upon our nightmares to pursue their own agendas.

My foundational work in the study of torture was the Argentine "Dirty War" in the late 1970s, a study that led me to the mass graves, to exhume and identify bodies of the "disappeared". Although some would deny it now, many Argentines greeted the overthrow of democracy in 1976 with jubilation. Finally, finally, someone was going to do something about the Communist subversives, the terrorists, the left-wing kidnappers.

And the military did do something. They *did* kill the revolutionaries who were threatening the stability of Argentina and the security of their children.

And then the soldiers tortured and killed labor union leaders who did not agree with their new economic plan. And then they raped and murdered school children who protested for subsidized bus passes. And then they kidnapped the librarians who shelved books they considered subversive, and they drugged and dumped into the sea anthropologists

and psychologists and priests whose thoughts and prayers they believed were subversive, too. And, as the soldiers cattle-prodded pregnant women, and as they stole their babies to raise as their own, many Argentines whispered under their breath "*por algo será*" – "they must have done something"—to deserve being brutalized. In the midst of this butchery, common citizens turned up the volume of their radios, so as not to hear the screams of their neighbors being dragged away.

In country after country, we have seen the Argentine experience repeated with such consistency that we must cease to consider it "Argentine" and realize it is universal. The Nazis "invented" disappearances in the 1940s, the French used torture in Indochina and Algeria in the 1950s and 1960s, and U.S. troops have recently—and proudly—filmed themselves sexually assaulting prisoners in Iraq.

This drama called "torture" translates very well across the world stage. The scenery and motivation of the actors may change, but the central characters remain the same: the child we would do anything to save (this can either be a flesh-and-blood child or a metaphorical one, such as *Lebensraum* or Democracy); the stranger who threatens this child (who has been called, according to the era, the "Jewish menace" or the "Communist" or "Islamic radical") and the protector we empower to torture in our name. It is on this stage where our personal fears melt into the economic, political and social interests outside our homes. It is where our personal choice mixes with the policy of the State.

It's a simple truth that most acts of torture are committed by States—by their agents or their proxies—in pursuit of their own ends, instead of by parents pushed by extreme events. Indeed, if we follow the letter of international law, torture—let us call it "certified" torture—can *only* be committed by States. According to Article 1 of the 1984 Convention against Torture and Other Cruel, Inhuman or Degrading Treatment or Punishment, "the term 'torture' means any act by which severe pain or suffering, whether physical or mental, is intentionally inflicted on a person . . . when such pain or suffering is inflicted by or at the instigation of or with the consent or acquiescence of a public official or other person acting in an official capacity."[1]

This prohibition against States employing torture is so deeply entrenched in customary international law that it falls under the category of *jus cogens*, meaning there is no greater class of prohibition. Torture, like slavery and genocide, is something so forbidden, so dishonorable for a soldier to engage in, that, even in times of total war, there is no legally-acceptable excuse for it, ever. No justifiable situation. No escape clause.

Yet, regardless of the weight of this prohibition, regardless of the fact that the overwhelming majority of religions, cultures and national legal systems throughout the world openly condemn this practice, a number of States do, indeed, torture. This is the case, sadly and shamefully, of the United States in its recent "War against Terror". As a

report from Human Rights Watch notes,

> The recent capture of high-ranking al-Qaeda suspects has rekindled a debate in the United States about whether torture is or should be used during their interrogation. Many Americans—including, apparently, U.S. officials—are unaware of the absolute, unequivocal prohibition against torture or other cruel, inhuman or degrading treatment of any person, including terrorist suspects. The right to be free from such mistreatment is one of the most fundamental and unequivocal human rights. As the United States confronts terrorism, legitimate national security needs, public anxiety, and the desire for retribution may give rise to the temptation to sacrifice certain fundamental rights.[2]

In this last sentence of the excerpt above, we see those two, pressurized streams, so integral to the Argentine Dirty War, converge once more: "national security needs" and "public anxiety". Certainly, there are real threats to our security. Certainly, there are terrorists, and we must stop them and kill them, if need be. However, in the face of this reality, the U.S. government plays upon our anxiety, continually ratcheting up the threat levels, forever implying a "dirty bomb" is about to be detonated in the United States. Our leaders characterize prohibitions under international law as a coddling of terrorists, to such a point, I now fear, that U.S. public opinion regarding torture is alarmingly close to "*por algo será*". Do we torture in Iraq and Afghanistan and Guantánamo Bay? "Well, they must deserve it," seems to be the response of a good many people. That is because we believe "our government knows what it's doing."

Indeed, I do believe the government knows what it's doing. While I accept the thrust of the Human Rights Watch report, I do disagree on one point: U.S. officials cannot possibly be unaware of the prohibition against torture. As a result of Eleanor Roosevelt's unwavering vision, we helped draft the United Nations' Universal Declaration of Human Rights, article five of which proclaims, "No one shall be subjected to torture or to cruel, inhuman or degrading treatment or punishment."[3] In the 1940s, we judged Nazi torturers at Nuremburg. In the 1990s, we judged Serb torturers in The Hague. And, ever since the violations we committed in the Vietnam War, we have placed such emphasis on soldiers' respect for the Geneva Conventions, I can only assume that, when our troops tortured in the Abu Ghraib prison in Iraq, this was the result of a wider policy, either of omission or commission.

In the end, no matter how hard States try to bend international law, if they want to torture, then they either have to do it in such extreme

secrecy so that we never find out, or they must convince us it is something good. That is why I take a personal approach in *The Pear Tree*. That is why I draw upon my personal fears and frailties, because they cannot torture as easily, or as frequently, if we deny them our permission to do so.

In a time when lawyers and soldiers, politicians and even presidents support the use of torture, the only hope is that you and I, our mothers and our fathers, our next door neighbors and our friends, reject torture, reject it for what it really is—the most demeaning, degrading and dishonorable act we could ever commit as human beings. If we reject torture, not because the law tells us to, or because our spiritual or political leaders advise us against it, but because we feel it in our bones, in our hearts, in our homes, then we may be able to rescue, amongst all this human misery, the very best in ourselves.

In the following pages, I make a personal argument against torture. Whether you are convinced by it, or not, is entirely up to you.

Eric Stener Carlson
May 2005

Chapter One

Insomnia

Tonight, I sit in front of my computer. The hum of the fan cooling the disk drive, the sound of my voice as I read each word aloud that flickers on the blue screen. Correcting. Erasing. I am the last one in the office tonight.

I have several pictures taped to the front of my desk. A photograph of my wife, Luján. Her long, dark hair pinned up by John Lennon sunglasses, elbows back, leaning against an iron-work fence. Her dark, Argentine eyes. Her high, proud cheekbones. One moment captured from our graduate school days in New York. A photograph of Hemingway when he was old and beautiful, his beard full of butterflies, like Lorca once said of Whitman. And a quote from Isaiah, chapter 32, verse 13: "And the work of righteousness shall be peace, and the effect of righteousness quietness and assurance forever."

The security guard, uniformed-blue, walks through the hall, checking doors, making sure the teapots are unplugged for the night. The photo-sensor beeps as he scans his ID, and the door closes behind him with a "click". Quietness. Assurance. Peace.

I haven't been sleeping well lately. I mean, some nights are better than others. But not tonight. Tonight is a staying-awake night, a staying-alert night, a night like Martin Luther had, when he sat alone with the inkwell cocked in his left arm with the Devil staring back at him from the dark corner of his room.

I work as "Expert-On-Mission" for Physicians for Human Rights at the International Criminal Tribunal for the Former Yugoslavia, in The Netherlands. My father has asked me several times, "What *is* an Expert-On-Mission? What exactly do you do?" The short answer is: I make studies of other people's pain.

I work for the sexual assault investigation team, and I do for them what I do best—reading and writing but certainly no arithmetic, because I am terrible at math. I've had little use for exact things like algebra and the periodic table of elements. No use for *scientific* rules at least. But I am a true believer in the Universal Declaration of Human Rights.

Every day I walk to work, past the shop that sells Japanese tea antiques, past the French bakery, past the Peace Palace built by Carnegie out of remorse for his millions made, and I follow that long, cobble-stoned path through Scheveningse Park. Sometimes, as I approach the Tribunal,

The Pear Tree: Is Torture Ever Justified? / Eric Stener Carlson

I pause beneath the large, light-blue U.N. flag, the continents snapping in their crest of white laurels, before I make my way to the first security booth. I empty my pockets of keys and coins, put my cheap leather briefcase through the X-ray, pass through the detector. I scan my ID over the photo-sensor, pass through one, two, three revolving doors. I walk up to the third floor and check my in-tray for faxes. The investigators have already dropped a pile of witness statements translated from Bosnian-Croatian-Serbian to English on my desk. I read the victim's name on the first page, and, thus, the workday begins.

I analyze the rapes committed in certain detention camps, villages and schools, forests and barns, carried out by or against Muslims, Croats and Serbs in this recent war of "ethnic cleansing". Not just rapes—every form of sexual assault imaginable and, after two years of this work, I can imagine just about anything. That's one of the reasons I can't sleep tonight.

I'm suffering from what's called "secondary-stress", a condition common to human rights advocates. It comes from reading the testimonies I read. And actually, I lied about not doing arithmetic, though it's really just simple math I do: I add up the number of vaginal rapes and anal rapes, blow jobs, cunilingus, analingus, and forced masturbation that I come across, circling them with pink, yellow and green hi-lighters. Then I design columns of data on Excel and Word, with neat, intersecting rows of perpetrator names, dates of assault, numbers of women who reached the clinics in time to terminate their unwanted pregnancies, those who did not. . . . At the end of my reports, I usually reserve a section for the "especially-heinous" crimes on which we should focus our limited resources. Which one of the mass-rapists should we pursue?

None of what I read has happened to me. I know. But absorbing these atrocities five days a week darkens the already dark, deep water inside of me. It touches me, frightens me. No matter how many doors I shut inside, I cannot numb myself entirely from 9:00 a.m. to 5:30 p.m., while I skim through the fragments of other people's lives, which often start something like, "He was my husband's best friend for thirty years, we used to drink coffee together. But the day the war began, he broke into my house and raped my nine-year-old daughter in front of me. Then he slit her belly open with a hunting knife. . . ."

It's called *secondary* stress, because I'm not the victim, the one whose humiliation some bureaucrat vivisects, safe behind his desk. I've never been raped. I have no scars on my back. All I really have to show is the groove in my right canine, from where I grind my teeth at night, and a slight ringing of the ears. And this insomnia. But I'm the one who watches the crime unfold from the personal data page until the translator's certificate of authenticity.

Right now, I'm sitting here writing this sentence, and I'm worrying about how each word sounds, and wondering whether the last book I read by Camus, *A Happy Death*, is influencing my writing style, and if,

as Camus wrote, they still sell pickles on the streets of Prague. I hear the familiar monologue inside my head on the accuracy of translations and whether, one day, I should be more serious about learning French.

My mind wanders, and I think: "Tonight is spaghetti night at home". I know that, because I bought a jar of *pesto rosso* in the supermarket yesterday, and Luján is in our kitchen, preparing dinner late. And she'll save me some and keep it on the stove, so when I come home, I can warm it up. I know all of this is true. But I can't help thinking: that's not what's going on.

I can't help thinking that she's forgotten to buy oregano, even though I know the bottle's on the first shelf above the range, and that she's putting on her coat and going outside. And I know our neighborhood's safe. But some junkie is standing on the corner. And I know the street's well-lit. But he's got a switch-blade, and the bushes of the park are so near by. He tightens his grip on the handle, and I blame myself for having left her alone.

A psychologist friend of mine tells me it's understandable to have these violent fantasies, what he calls "a natural reaction to dealing with unnatural acts". So, naturally, I take home with me these stories of women being sodomized while their husbands are forced to watch helplessly. I take the stories to bed sometimes or stare across the table at them while I drink my morning cup of Earl Grey tea.

Sometimes, as I climb the three flights of stairs to our loft coming back home from work, trying not to stumble on the impossibly-fractured Dutch steps, fumbling for the keys, my heart beats terribly, and I pray to God Luján's alright. I see myself opening the door onto a struggle between Luján and a rapist in our living room. I count how many steps it takes me before I can tackle the masked figure, decide quickly whether I should throw my briefcase at him or kick him or bite him or strangle him with the telephone cord or kick him through our large windowpane overlooking the cathedral.

I am acutely aware that the things I read about are done by what newspapers call "ordinary" people. The soldiers weren't soldiers until the war began. They were librarians. Shopkeepers. Professors of English literature. Some were ordered to do it. And they did it. Others, as they excuse themselves through the bullet-proof podiums in court, "just snapped". And they did it, too.

When I experience this surge of paranoia, this surge of fear, I tell myself: yes, I could kill to defend my wife. But that's something different from the kind of acts I read about. I feel incapable of harming anyone in *that* way, incapable of the perversion called "torture". I could never use the hot coals, the leather restraints, the penetrating needle. That would go far beyond protecting my family, beyond anything I could live with.

As long as I maintain the belief that there's a difference between me and Stalin and Pol Pot, I can survive reading all these horrors. I can

do my job and sink up to my neck in shit if I have to, and I'll get by. It's the sense that there's a right and a wrong in this world, a good and a bad—however naïve that sounds—that gets me through the day; the confidence that, no matter what happens, I will never obey the command to torture. This belief is what's gotten me through all these years. It's even eased my fears a bit. Until tonight.

There's a half-forgotten memory crouching in the shadows of the room, a story I've known most of my life, although I haven't spoken it aloud more than once or twice. It's a story of a child's death, a wrongful death, a story of all the dark nights pierced with darker fears I've had to live through, ever since.

It's been the barely audible, white noise in the background to all the speeches I've ever made on human rights, the running commentary to all the articles I've ever written against the use of torture. It's that slight gnawing on the bone that troubled me while exhuming bodies in the mass graves of Argentina, while taking photographs of street children in the slums of Peru. Its chip-chipping sound rises to crescendo levels in this insulated room tonight, and no moral platitudes or nurtured belief in my self-control are going to muffle it.

Tonight, in the glow of this blue screen. Tonight, in this room full of empty chairs and unkempt desks, I will begin to write the words I have written and deleted again and again, hardly knowing how to write them, half-afraid of finding how. And in doing so, I look into the face of this grinning blackness.

Chapter Two

The Garden

I was born on the Iron Range of northern Minnesota. My father was a mining engineer, having begun life as a cowboy in South Dakota during the Depression. My mother was a high school English teacher from Colorado Springs, with a penchant for Dylan Thomas. We lived in a small, white house in the village of Hoyt Lakes. Almost everyone in Hoyt Lakes worked for the iron ore mine, and absolutely everyone was either digging out from the last, or preparing for the next, winter.

My mother has told me there were picnics and fourth-of-July parades. I have seen photographs of my sister, Janice, decked out in her tall, red hat with swinging, golden tassels, playing the French horn in the high school marching band. I've heard stories of water-skiing and swimming in the 10,000 lakes. So there must have been warm days, shirtless days. But I find that hard to believe, hard to feel it in my body's core.

My memories of Hoyt Lakes are almost entirely composed of blizzards and ten-foot snow drifts, of unwrapping Christmas presents by our fireplace, of the ax my father used to test the lake's icy cap, leaning in the garage amongst the bent and twisted aluminum snow shovels. And tobogganing, the glimpse of my father's parka'ed back, as he towed me and my two brothers and sister in the sled behind his snowmobile. We rushed across the frozen lake, chips of ice flying up at our raw, tingling faces like sparks from a blacksmith's hammer. I do not remember one single, summer day in Minnesota. When I look back, everything is snow. Everything is ice.

When I was five, we moved to the island of Tasmania, just across the Bass Strait from the Australian continent. My father had been hired to supervise a bauxite mining operation near the small town of St. Hugh.

I remember the shock of leaving that horrible cold, where I was always being bundled up in my snowsuit before being sent off to pre-school, layer upon layer of sweaters and vaseline coating on my chapped lips, chains wrapped around snow tires. Suddenly, we arrived at this tropical island, where I ran about in short sleeves almost year round, green zinc sunscreen perpetually spread across the tip of my nose. I can still feel the burning pain on the backs of my legs from the red, hot vinyl of our station wagon seats, the heat absorbed from an entire day parked at the beach. As I hopped across the wading pools, the crusty mussels clenched on the rocks cut the soft parts of my feet.

The Pear Tree: Is Torture Ever Justified? / Eric Stener Carlson

Recalling all the new elements that burst around me—the heat, the air, the sea, the blue, blue sky—the image that sticks out in my mind is the vegetable garden in our back yard. You could grow anything there, without fear of frost or snow or hail. We had strawberries, celery, tomatoes, year round. And the carrots! I remember pulling them fresh from the ground, washing them off with the green garden hose and quickly crunching them. They were sweet in my mouth, the gritty taste of black Tasmanian dirt deeply embedded in their rings.

But beyond the tastes and textures of the garden, my memories eventually lead me to the figure of a man, distinct from the warmth and wonder the plants awakened. He is a man whom I learned to respect, a man whom I have come to fear. He is pressed into my memory of the garden, inseparable from the long, wooden stakes we drove into the earth to bear witness to the names of rising sprouts.

His name was Alfred Foster, a former constable from our town who had served the community for over thirty years, although he was retired when I knew him. My father hired him as a night watchman at the mine, and, as the years went by, they became good friends. Foster would often come to our house to visit, usually unannounced and in the early morning, bearing boxes of oranges and grapefruit as presents. In my mind, I see him now: a wrinkled man in a crumpled coat, limping through rows of vegetables, poking plants with his cane, offering my father interminable advice about when to plant, when to harvest—lecturing him on which shoots were getting too much light and what should be done about it.

For all the richness of the soil, however, there was one plant that never grew in our backyard. It was the pear tree, a withered brown shaft between the garden and the fence, the same height as me when I was six. For some reason, and I don't know why, I remember asking Foster when it would grow, and he said to me, with heavy tobacco breath, that pear trees are special things; they need seven years from the time they're planted until they bloom. In the meantime, you have to cut back the branches, dig at the roots. You have to be harsh with the pear tree, and, in the end, it *will* grow. Cut. Clip. Cut again. And wait.

What Foster said stuck in the back of my mind, and I drew upon this information as if from a secret store, keeping count as the years went by. As my brothers and I made forts in the mud and the tall, green grass, I waited to see if my pear tree would bloom. But it never seemed to change as the years went by, remaining fixed at my height when I was six years old, while I turned seven, eight, nine. . . .

Chapter Three

The Stranger

Most people I know think of Australia as the perfect country. Snorkeling in the Great Barrier Reef. Socialized medicine. Kangaroos hopping past barbecues laden with prawns on a lazy afternoon. But life in the mining towns of Tasmania is far from picturesque.

Life in St. Hugh was much like life in any Midwestern suburb in the United States: protected, confining, repressed. However, up in the brush-covered hills nearby, and alongside the turns in the dusty roads which led to the mine, violence ran wild in the company towns, in their bars and on their street corners. Drug abuse filled the concrete homes, and the children, the many children, of the marginal or unknown fathers, played in the shadows of the great piles of earth that many moving machines had displaced in search of ore.

Starting when I was around seven years old, it seemed to me children were always being kidnapped on the island. This, surely, was an exaggeration. But through the eyes of a child—through *my* eyes—the situation looked much different. The public service announcements on television—"It's ten o'clock, do you know where your children are?"—the occasional face of a missing child on a milk carton, and my parents' "stay away from strangers" speech over scrambled eggs and bacon deeply impressed upon me that I had to be on my guard. The ferocity of the kidnappings, although infrequent—like the shark attacks which occurred in the bay where we swam—fanned this fear in me, and I believed myself most susceptible to them of all.

At times, it seemed as if the winding path down Salamander Hill from my house to my elementary school was filled with Strangers in their slow-moving, black sedans. They seemed to surround me, like shadows nestling beneath the blackberry bushes, like tiger snakes in the long grass, waiting patiently the way only Strangers can, holding out their fancy dollies or their bags filled with mint candies, rehearsing the Big Lie—"Your-mother-is-in-hospital-we-are-good-friends-you-should-get-into-the-car-with-me-because-she's-calling-you-to-her-bedside-dying". And I knew the day I let down my guard, the day I really believed my mother was sick and needed me and I got into that black sedan, I would disappear like all the rest.

In this way, the idea of the Stranger became engraved upon my early childhood, like a deeply-cut lithograph, inking and re-inking in my mind the archetype of the person I should fear.

The Pear Tree: Is Torture Ever Justified? / Eric Stener Carlson

For two years in a row, I entered the Municipal Council Crime and Safety Poster Competition, sponsored by the Crime Prevention Advisory Council. In 1978, I even won second place for drawing a poster warning drivers not to drive recklessly. From colored paper, I had cut the figure of a car careening off the road, crashing through the barriers and into the cavern below—a reckless driver was behind the wheel. (I had spilled a bit of glue on the black paper road, and, although it dried clear, I often wondered if this sloppiness robbed me of first place.)

But I had drawn my masterpiece the year before. I won first place, a check for ten dollars, and a Certificate of Merit, signed by the Local Council Clerk. (What impressed me most of all was that the letter had been addressed to "Master" Carlson.)

My winning poster was of the Stranger, a man pink in outline but white on the inside, his left arm stretching out towards you, his hand becoming larger than his head. His four, elongating fingers, now even longer than his pink car left running behind him, held a real lollipop which I had glued onto the hand, with candy and wrapper and stick. (I think this was my mother's idea—for authenticity.) It's strange how I can remember everything about the poster so clearly, except my slogan. It was something like "Don't Ride With Strangers!" or "Don't Accept Candy From Strangers!", and I was very proud of it.

Then something happened to reinforce my obsession with kidnappings. A little girl named Lisa Powell disappeared on her way home from school. There was no ransom note. No phone call claiming responsibility. One witness had seen Lisa step into a tan-colored car one day after school, and that was it. We all assumed Lisa was dead, but no one knew for sure.

Lisa and I were about the same age, seven or eight years old. We both attended public schools in the area, both played in the same parks filled with the enormous front-end-loader tires from the mine where our fathers worked. We were practically neighbors, but I had never met her. I didn't know the color of her hair, her eyes. I didn't know what her favorite ice-cream flavor was, if she liked boys or not, if she liked reading *The Secret Seven* while hiding behind her parlor chair like I used to do. In all ways, she was, and still is, an ambiguous character to me. But I immediately identified with her the day she disappeared: she was a child, like all of us, and if it could happen to Lisa, then I was sure it could happen to me.

Much of Lisa's story has been handed down to me through fragments of adult conversations at dinner tables, abbreviated and often coded references to "that poor little girl" in the days, weeks and years that followed her disappearance. But I felt the emotional tremors touched off by Lisa's disappearance, *"en carne propia"* as they say in Spanish—in my own flesh.

The entire community was unbalanced by the shock. "This sort of thing just doesn't happen in St. Hugh", people said, although I had long suspected it could (and if they'd only paid more attention to my

poster, then maybe Lisa never would have disappeared). As a result, our parents were more careful to monitor where we went. The frequency with which they gave us the "beware of strangers" speech increased.

One night at the mine, months after Lisa had disappeared, Foster was griping to my father about the slow pace of the investigation. In fact, Foster had been pestering him for weeks. There were no suspects, no leads. They just didn't make policemen like they used to. If he were in charge, he said, he'd have it wrapped up in no time. My father, anxious to get rid of him, said: "Then why don't you take some time off? Go. Solve the case."

And that's exactly what he did. Calling in some old favors at the local police, Foster returned to the work he loved. He re-read investigation notes, combed through original interviews, re-interviewed everyone on the witness list.

One day, he visited an elderly woman from Lisa's neighborhood. At first, talking to her must have seemed a waste of time, until she mentioned that on the night of Lisa's disappearance, a neighbor of hers, Sean Roberts, who lived across the street, had pulled his car into the driveway and then run into his house. Then he ran out again, looking very agitated, his hair still wet from a quick shower.

Consulting his notes, Foster explained that Roberts had already been interviewed and discarded from the list of suspects. His car was blue, not tan. "But that's what I tried to tell the other policemen—he's got two cars!" the old woman shrieked. "One blue, the other tan. He drove the tan car the night the little girl disappeared, and he's locked it in the garage ever since!"

That day, Foster arranged for Roberts to be taken in for questioning. Roberts insisted he was innocent, and he refused to talk until his solicitor arrived. He owned a tan-colored car, yes, but it was clean, and there was no evidence of an abduction. Foster continued asking questions. Roberts still refused to talk. Then Foster asked the two constables in the interrogation room to leave for a moment, so they could have "a little bit of privacy."

Hours later, when Foster invited the two constables back inside the room, they found Roberts sobbing, and screaming "Lisa, Lisa!" Shouting how he'd raped and killed her, describing the burial site. Based on Roberts' directions, the police soon found the gravesite and recovered Lisa's body. On the basis of this evidence, Roberts was brought to trial for the murder of Lisa Powell and was sentenced to serve the rest of his natural life in prison.

His last, great case completed, Foster went back to working night shifts. He was a hero to everyone, especially to the parents of St. Hugh. And why not? Their children were safe, and Foster was the one to thank. I, too, thanked God for Foster, for, in the wake of Roberts' capture, I felt a sense of safety that was palpable and comforting. I wrapped myself in the knowledge that I was safe like a warm blanket, knowing there was one less Stranger on the island.

Chapter Four

The Millstone

It's been almost three decades since Roberts was captured. As I've passed through the stages from childhood to adolescence to adulthood, I have often pictured the room in which his interrogation took place. Of course, I've never seen the actual room, and I have no idea what it really looked like. But, on nights like this, the images I conjure up seem very real to me.

The stucco peels in small strips from four dingy walls. An old metal fan, with the guard half-falling off, makes the cobwebs rise and fall in one corner of the room with each rotation of its electric head. One bare light bulb hangs from the center of the ceiling, swinging carelessly. A faint buzzing sound comes under the door, from the fluorescent lights in the hallway, where the two policemen slouch and chat nervously, hands in pockets, smoking, listening but unseen.

Roberts sits on the wooden chair, the only furniture in the room, his hands cuffed behind him, head down. Foster stands behind the suspect, wiping his face with a faded red handkerchief. He curses the stuffy atmosphere but smiles as he stares at his reflection in the one-way mirror, confident no one is looking back at him through the glass, that it is just an empty room. He breathes deeply. In one corner of the room, he leans the cane with which I always saw him hobble through our garden. He unbuttons the cuffs of his sleeves, rolling them up beyond his elbows. Roberts raises his head to cough slightly but still says nothing. Foster begins. . . .

As far as I know, Foster never told my father what he did to Roberts, although there was an unspoken understanding it wasn't exactly by the book. All that has come down to me are hints, vague allusions of possible abuse. One night by the pool at a summer dinner party, while spitting out watermelon seeds, I heard the word "duress" float from the adults' table, something I had to look up in the dictionary to understand. (Originally "*duresce*" from the Middle French for "hardness or severity".) "Good thing the girl's body was found," I remember someone saying, "'cause *duress* was used." It seemed to me such a strange word for causing pain. It still does.

Perhaps Foster "just" threatened to beat the hell out of Roberts until he confessed. Perhaps he "just" slapped him a couple of times. Or, perhaps, he used a wetted-down towel to half-asphyxiate him, so he wouldn't have to explain any bruises at the inquest. But all this is

speculation on my part, imagination. I offer no proof. There has never been any official suggestion that what Foster did was wrong. To this day, his record's clean.

If you ask my parents, they'll probably say I'm way off base. Perhaps what Foster used was just good cop tactics, forcible *persuasion* like we see TV actors using on late-nite cop shows. All you need is just one man, with a good, solid voice to convince the criminal to tell the truth. Besides, *you* know how children often exaggerate the stories they overhear.

But that's not the point. Whether better or worse than my imagination, my parents have long maintained whatever Foster did was justified. Yes, Foster may have broken the law. Yes, he may have even tortured Roberts. But then again, Roberts *was* the murderer, the child rapist. He was the Stranger with the lollipop glued to the elastic hand stretching out from the sedan whom we all feared. He was the monster who would kill and rape and kill again until he was stopped. The law had failed us. It had failed to protect little Lisa most of all, and if it took Foster and his methods to make sure Roberts would never harm another child again, then so be it.

When I lie awake in bed, I picture the interrogation scene again and again in my mind, hoping that the repetition of metaphors will bring me some release. Behind the locked door of that small interrogation room, lie the mystery and the passion. The pain, the consolation, the justice, the travesty, and the delusion. But what I am looking for most of all, when I turn the doorknob and walk inside, is knowledge.

The room has come to represent everything I feel about the struggle for human rights, in the way Jesus' suffering on the cross distills for me the very essence of Christianity.

The cross. I think of the silver one hanging around my neck. It's a gift from Luján to protect me when I'm in war zones. Come to think of it, it's the most enduring lead we have to the torture and murder of Christ two thousand years ago at the hands of the Roman police. How would I investigate that crime, I wonder? How would I eliminate the contradictions in the witnesses' testimonies with my hi-lighter? Matthew, Mark, Luke, John. No last names, no addresses. And then there's all that squabbling about the inaccuracies in translation from the ancient Greek...But my mind's wandering. It's this insomnia.

Ever since I can remember, I've believed there's something good in all of us, innate, something at the core of our humanity that tells us it's right to care for others and wrong to harm them. I was the one who ran out onto the driveway after the thunderstorms, flinging bloated worms back onto the grass, before the Australian sun could rise and dry them out. I was the Boy Scout who, when he repeated the Scout law, was bothered that the order of the words was "to obey the Scout law" *before* "to help other people at all times." I used to think, as I repeated in my

uniform, buttoned tight across the belly: "Why obey the law if it doesn't include helping other people?"

My father has had a great deal of influence on my conception of justice. He's always been larger than life to me, an icon of the American dream. I never tired of his stories of the last cattle drives across the West in the 1940s, the building of the great dams and the construction of mining cities deep below the earth. All these dreams, all these creations, he participated in. But he was not just the cattle-hand turned man of science. He was also the second-lieutenant in the U.S. Army reserves. He was the college football hero from Colorado State. He was the Lutheran Sunday school teacher, the scout leader, the mayor of Hoyt Lakes who never took a bribe for the full ten years of his political career. He always tithed to our church, even when he had four, small children to support. To me, he was everything that was honorable and just. He still is.

Most of all, what I loved in him was the way he made me feel protected in lightning storms and blizzards or just in the simple darkness of childhood nightmares when I thought monsters filled my room. This must be what being a father is all about, this must be what love is all about. Your son, your daughter, is the most valuable thing you'll ever have. You'd do anything to protect them.

That's why, when I think of Roberts raping and killing Lisa and hiding her in some dank hole, something deep inside of me convulses. A cold and terrible hand touches me, and I think, "My God, how could anyone do such a thing?"

There should be some automatic brake inside of us, a barrier in our brain that stops us from committing such crimes. My mind runs to Mark chapter 9, verse 42: "And whosoever shall offend one of these little ones that believe in me, it is better for him that a millstone were hanged about his neck, and he were cast into the sea." I know, the one, unforgivable sin is *supposed* to be blaspheming against the Holy Spirit. But I can't think of any greater crime than harming a child, for what is more holy than a child's life?

That is why, for these many years, I have agreed with whateve Foster did. In fact, when I overheard how Foster had solved the case (I must have been eleven or thirteen at the time) I was filled with a certain— I can't say happiness, but—*solace*, because Roberts had been the monster who hunted me in my dreams, the Stranger who made me run quickly home from school, limping with my heavy backpack. Wasn't it better for me to be alive and to grow up and be free than to hide, a terrified, sleepless child, waiting for him to snatch me from my parents?

Weren't we *all* better off for what Foster had done? And if what he did was wrong, wasn't it the best thing we could do in a terrible world? Like the Lutheran Pastor, Dietrich Bonhoeffer, said of his participation in the plot to kill Hitler, "It is better to *do* evil than to be evil."

But in the last, few years, a thought has been turning over in my

mind, a simple thought gathering strength as I lie awake: If Lisa was someone's child, someone to be protected and cared for, then wasn't the same true for Roberts? Or did he stop deserving that protection? Did he become motherless, fatherless, the day Foster *suspected* him of killing Lisa?

And what had Roberts suspected of Lisa? That she was a little whore? That she deserved it? Or maybe he was convinced she was Satan herself and had to die for all our sins to be absolved. If what Foster did was "good" in his eyes, what was so different in his methods, except in the object of his abuse and perhaps the extent? And if it was "evil", how different, really, is *being* evil from *doing* evil?

Recently, as I was scanning my bookcase, I came across a battered copy of *On Liberty* by John Stuart Mill, wedged tightly between the King James *Bible* and *The Great Gatsby*. In the dog-eared pages of the book, I read the words I had underlined with a younger hand:

> [U]nless we are willing to adopt the logic of persecutors, and to say that we may persecute others because we are right, and that they must not persecute us because they are wrong, we must beware of admitting a principle of which we should resent as a gross injustice the application to ourselves.[4]

I never thought those words would apply to me, but what more can I say about what Foster did? What better excuse can I offer for his abuse, except that Foster was right and Roberts was wrong? As a child, I had adopted the logic of the persecutors.

But tonight, I am compelled to search for some sort of demarcation between myself and Roberts. In this dim, fluorescent light, I can perceive little difference between Foster's presumed act of torture, and my benefiting from it. Being evil. Doing evil. Benefiting from evil. Foster and Roberts and I are tied together in whatever happened in that interrogation room so long ago.

I need to know whether the pear tree will bloom if we cut its branches back, if we dig at its roots. I need to know whether we do more right in the end by torturing the Strangers among us to save our child. Or whether we are somewhat less because of what Foster did, whether we are somehow damaged and can't grow back.

Can I continue writing articles on the universal application of human rights, continue drawing my damnably-straight charts on the number of women raped, since I have accepted this brutality, since *I still accept this brutality?* Because, for all I profess to the contrary, I am still grateful for whatever Foster may have done —call it what you like, duress, brutality or torture—and I have bathed pleasantly in the comfort it has given.

In these pages, I will trace where I've come from since that quiet night so many years ago—from Australia to South America, from the Caribbean to the Balkans—to try to make sense out of what I've seen, to try to find out what it is I really believe in, behind this facade of words, behind this mirage of advocacy. I need to find out if anything is still holy for me. Most of all, I need to know if one more sleepless night, leaving me desperate with thoughts that the killer was free and hunting me, might not have done me more good than all the nights of tranquility Foster's actions bought for me.

Chapter Five

The Fortress

In Tasmania, my two brothers and I would camp out in the wooden fort our father had built for us. It stood on the vacant lot behind our house, between the stable he had built for our Shetland pony (named Buckshot) and the garden. From the top, open-air level, you could slide down a metal pole, like a fireman, to the room below. On clear, starry nights, we would unroll our sleeping bags on the roof and look out at the wide Tasmanian sky.

One day, it occurred to me that we brothers formed the secret "Club of the Three Magicians"—although I never told my brothers this, because it was a secret even from them. I took out the old, collapsible aluminum ladder from the garage and dragged it across the lawn to the fort. Mounting it, wobbling terribly, I wrote out our title just above the entranceway in large letters with a stubby, graphite pencil. Soon after writing it, however, I was overcome with guilt. For days, I worried my brothers would be angry I had named the fort without their permission.

But nothing ever came of it. My lightly-drawn letters were impossible to make out against the boards' rough, thorny surface.

On those special nights, when we three magicians camped out, we would sometimes see meteors stream across the sky, flare and disappear. I would often try to find the Southern Cross, and, almost always unable to, I would pester my oldest brother, Jimmy, to keep on pointing until I did. Jimmy would guide me by the brightest stars, asking, "See that one there, where I'm pointing now? Go right, go right. There, you see, straight up and down?" Usually, I couldn't separate the cross from the confusion of the other stars, and I would just nod and say, "Yes" to please him. I was afraid he'd get frustrated and turn his back to me and talk, instead, to my other brother, Christopher.

But sometimes, *sometimes*, I would see the cross there, amongst the mass of stars, and I would lie back on the wooden boards. Focusing on those bright lights, absorbing the special warmth of the red plaid lining of my sleeping bag, feeling safe between my two brothers in the fortress our father had built for us. . . .

Looking up at the night sky, I could distinguish the Southern Cross so clearly, as if it were stitched into the red and blue of Australia's flag, when we sang "God Save the Queen" at Cub Scout Meetings.

But I was not in St. Hugh, and my childhood in Tasmania was almost a decade away. It was the late 1980s. My family and I had

moved to Ohio, right around when Ronald Reagan assumed the presidency, and I was now on a high school exchange program in southern Argentina for the summer. It was the last night I would spend in Santa María, a dusty, rural village, named after the Virgin Mary.

I was looking up at the stars through the holes in the plastic tarp ceiling in Don Amado's soon-to-be-completed dining room. Don Amado had befriended me during my stay in Santa María. He was a good man, a poor man who lived in a leaning brick and stucco house. That night, he was throwing a going-away party in my honor.

Don Amado had adopted me as his own son, or, rather, his own grandson, for he was an old man. He had just a few teeth and a deep bend in his back, but he always had a wide smile for me and a huge *abrazo*. The day Nati first introduced me to him, he said, "*Mi país es tu país.*" —my country is your country. He really meant it, and he always asked how things were going at school. Like his name means in Spanish, Don Amado was beloved by me, and I was honored to spend my last night in the village as his guest.

As I stared at the plastic sheeting roof stapled to random timbers here and there, rippling in the night wind, Nati came rushing in and set down a towering pile of small, crescent-shaped *empanadas*. Then she ran back to her house for more. Nati was an older student at our high school and Don Amado's next-door neighbor. She and her young cousin had been baking the whole day just for me.

Nati spoke English with a slight southern drawl, a legacy from her year abroad in a small town in southern Texas. She told me to start eating the first batch of *empanadas* while they were still warm, and, shouting "*Más empanadas, vení, vení,*" to her cousin who was lagging behind, she hurried back to the kitchen for another platter. She added, almost as an afterthought, the typical Argentine "*Ya va*".

I found Nati, several years older than myself, absolutely captivating. For the past two months, through late-night conversations on the poetry of Alfonsina Estorni and Gabriela Mistral, I began to fall into a quasi sort of love with her—a love teenagers build out of mutual loneliness and their incapacity to understand the cruelties of the world, a love adolescent embarrassment never lets us speak.

The year I was studying in Santa María was crucial for the survival of Argentina's democracy. Only a few years before, the mountains on the outskirts of the village had been the base of operations for a left-wing guerrilla insurgency. They were also the site of the military dictatorship's bloody counterinsurgency, a showcase of repression that branded the word "*desaparecido*" into the international vocabulary. From 1976 to 1982, in their hyperbolic reaction to the terrorist threat, the dictatorship "disappeared", or, to be more precise, kidnapped, tortured and murdered, somewhere between 9,000 to 30,000 people. The great majority of victims were non-combatants: priests teaching the poor to read, teenagers protesting an

increase in the bus fare, students, doctors, anthropologists, sociologists, and other similar *subversivos*.

The Armed Forces' rule ended in 1982 when they failed to wrench the Falkland Islands from Mrs. Thatcher's grasp. The torturers had sent conscripts my age to face death on those cold rocks, while they waited comfortably back home in Buenos Aires. I had been twelve then, and I was now seventeen. In those years, I had changed fundamentally, radically. I was my own person with my own thoughts—or so I believed—fiercely independent, full of adolescent anger and anguish and angst. In Santa María, however, hardly anything had changed since the war. In fact, there was a good chance that, if anything changed at all, it would be for the worse.

Once more, a threat to the fragile democracy arose. Soon before I arrived, some high-ranking military officials had been called to testify at the War Crimes Tribunal, but they had refused and sought refuge in an Army barracks. The uprising began that Easter, with tanks being mobilized in the streets and fear in every home. Suspecting he would be the last democratically-elected president in the history of Argentina, President Alfonsín gave in to the military's demands and proclaimed in his famous speech, "The house is in order. Happy Easter!"

The Dirty War, coupled with the Falkland Islands tragedy, left an indelible mark on the Argentine people, fracturing them into scattered groups of hatred and fear. That summer, the judges had not yet handed down their guilty verdicts on the leaders of the Junta, verdicts that would later be annulled by several presidential amnesties. No one knew yet that only a handful of torturers would ever spend any time in jail and that we'd soon find the rest of them standing in line with us to catch the bus or sipping a *café con leche* at the restaurant tables next to us.

During my last night in Santa María, I was oblivious to all of this. The *empanadas* were fresh—chicken, ham-and-cheese, spicy beef and onion—and left a taste of hot grease in the back of my throat and the desire for a dozen or two more.

Rinaldi, a local newspaperman, was also there to see me off. I hated Rinaldi, and I still do, but I suppose I hated him most that night.

Chapter Six

Of Love and Whores

Rinaldi advised the literary magazine at the second of two schools I attended in Santa María.

During the first week, the principal of my first school presented me to the class as the new Norwegian exchange student. In my rather limited Spanish, I tried to explain I was an American, but he insisted on describing to my classmates the geography of Norway, its desolate landscape, its endless ice and jagged rocks, all of which perfectly described Minnesota (if only he had left out the part about the fjords). I finally made him understand that my grandparents on my father's side were Norwegian—hence, Carlson—but I had been born in the U.S. Upon realizing his mistake, he kicked me out of the school.

As it turns out, my principal had been mayor of Santa María during the dictatorship, and his political career had been cut short by the reemergence of democracy. Because the U.S. government had, in some minor way, helped the British in the Falkland Islands War by providing them with satellite coordinates, he considered me *persona non grata*, a son of imperialists and whores. The day he kicked me out, I understood why the Spanish word, "*extranjero*", means "foreigner" but sounds like "stranger". I certainly felt like a stranger, having to give up my old friends and trying to fit in at the new school.

I hated the new school. I hardly had the energy to make friends after being expelled. My attitude was summed up in my journal that summer when I wrote, "I went to the new school, and it sucks. . . . *Here's something funny*: The education minister died, and so tomorrow we have school off. (One might think that he'd want school to continue.)"

There was one friend from my first school, however, whom I kept in contact with: Ursula, the village whore (*puta*). At least, she was rumored to be a whore, and, in a town like Santa María, people tended to treat you the way the rumor went.

One day, Ursula invited me over to her house. We drank tea and ate hard biscuits, and we looked through her family photo album. She proudly showed me photographs of her father who had died when she was very young. Black and white pictures with the edges torn, faded yellow strips of a man in an old suit I had never met and whom she barely remembered. We struggled to communicate, I in terrible Spanish, she in terrible English. It was really rather nice.

Then we came to the pictures of Ursula in a local beauty contest. She wore a tight black bathing suit and high-heeled shoes, and had struck a provocative pose. Instead of the chic cover-girl she longed to emulate, she came across as the cheap whore the village accused her of being. As she peeled off the photo from the sticky album and gave it to me to keep, she smiled. It wasn't a come-on. It wasn't foreplay. In her little house that afternoon, she shared her dreams of becoming a fashion model, and she didn't ask me for anything in return except that I have tea with her. It made my heart break.

If she were truly a whore, then that was, perhaps, the only time in her life a boy had come to see her in the daylight, instead of sneaking away with her at night for the ten sweaty minutes of which his girlfriend grudgingly approved. The good girls of Santa María understood their boyfriends needed to hump filth like Ursula. That was the price of being married a virgin: a necessity if their husbands were to treat them with respect. Whore—after I met Ursula, I wasn't sure what that word meant.

As I left Ursula's house, I saw my host mother sitting in her car. Lip-twisted, gray temples throbbing, fuming, she had driven me there and refused to leave until I came out. She was scandalized that I had gone to see "that girl". My alleged whoring, however, put me in good stead with her son—my host brother—Esteban. As I wrote in my journal:

> Everyone in town thinks, or, better yet, knows Ursula is a slut. . . . Esteban told me that it's okay to fuck her as long as nobody sees us together. What an asshole! I told him I didn't know her, let alone love her. He says it doesn't make any difference.

A few days later, Ursula mailed me the poem "Desiderata" by Max Ehrmann. She had hand-copied it in Spanish on the back of one of those "friendship" posters you can buy at the local *librería*. The poster was captioned something like "True friendship lasts forever" or "I think of you always" with a picture of tearful clowns and sad, round-eyed puppies. (I hate corny things like that.) I had to look up the hard words from Ehrmann's poem. I remember sitting there, with the dictionary broken open on my lap, overcome with emotion as she urged me not to be cynical about love. I never saw Ursula again. I don't remember why.

Not altogether satisfied with my alleged whoring, Esteban and his gang of hoodlums ridiculed me. They were under the impression some other friends I had finally made at school were faggots (*putos*). That was how the rumor mill was grinding in Santa María that day: I was an imperialist, Ursula was a whore, my friends were gay. I remember my host father sitting me down at the dinner table one night and asking me very seriously, "¿ *Vos sabés qué es un 'puto', no*?" ("You know what a 'faggot' is, right?") I almost laughed out loud.

But there it was. It was good to sleep with *putas,* but bad to be friends with *putos.* Not only that, I squandered my good, whoring credit by walking through the village alone at night, just so I could get out of that stifling house, and by going to the café in front of the plaza to write poetry. Everything I did seemed to be an affront to Esteban's masculinity and to his family honor, so he decided to rectify the situation.

Late one evening, seven or eight of us boys packed into a ridiculously small Fiat for a night on the town. We drove around for a while, until Esteban stopped the car in front of what he proudly proclaimed to be the "town faggot's house". He jumped out of the car and banged on the door, taunting the people inside. The boy's elderly mother came out—she was small and gray and reminded me of my grandmother—shrieking at us, running at the car with a broom in her hand. The boys swore at her and jumped back into the car. With the tires spitting up dust, we drove back home, everyone laughing, everyone enjoying the spectacle. Except for me. My stomach felt sick and heavy. After that horrible night, I tried to escape Esteban's grasp, but it was difficult because, as my guidance counselors insisted, "The family home-stay is an integral part of your experience."

A few nights later, we were at a birthday party for one of my host brother's friends, el Lobo, whose parents were out of town. It was an absolute bore. There were no girls, for one thing, which I thought strange, because, when I went out with my "faggot" friends, there were always plenty of girls. A drunken, brooding atmosphere enveloped the dimly-lit house, like the night we were squashed inside that tiny car. I felt trapped, and, actually, I was. The only door was locked, and all the windows were sealed with grates, a charming custom in Santa María where no one trusted his neighbor. Finally, after stumbling over empty beer bottles, I found el Lobo, lost in a haze of cigarette smoke somewhere in the back. After much convincing that I would soon return, I got him to open the door, and I went straight to Nati's house.

Out in the wonderful night air, Nati bought me a *milanesa* sandwich at a local corner-side stand, and we sat on rickety, wooden chairs, looking up at the moon, talking of politics and education, and I don't know what else. There was no pressure, no subterfuge. I can't remember a night I enjoyed more that whole summer.

The next day was probably the worst. Grant, an exchange student from Florida, who had also gone to el Lobo's party, called me on the phone, terribly upset, babbling about what happened soon after I'd left:

> Grant told me something horrible. They are always saying how macho they are, but last night they brought the town faggot into a room [the same boy whom they had taunted a few nights before] and *had*—or let him—

suck their dicks. . . .Truly disgusting. Only Grant. . . .and a few other kids didn't go into the room. Grant told me that to them it was just like going to a whorehouse!.Those self-righteous. . . . They said they're not gay, and they would like to kill all the gays, and then they get a blow job from one of them. They say that doesn't make them homosexuals, because the faggot was the one doing it.

It made me think back to the shower room scenes of my high school football team in Ohio, to the boys who were always swaggering about the steam-filled room with their dicks in their hands, shouting "bitch" this and "cunt" that, listing off the names of cheerleaders they'd ostensibly fucked that week, ridiculing the boys with smaller dicks, making jokes about how you shouldn't drop the soap in front of number 67, or he'd fuck you up the ass. How many of the boys on my team were the Estebans of this world? How many were oppressor by day, oppressed by night, in the hiding of their own inclinations, secretly afraid of acknowledging how badly they, themselves, wanted to see number 67 drop the soap.

And I have since wondered if that poor boy had any choice in coming to the party or if he'd been dragged there against his will, kidnapped right in front of his mother, with that poor, old woman with her shaking broom unable to prevent it. Sometimes I think, had I been working for the sexual assault investigation unit of Santa María, I would have found his name in my in-tray of witness statements: victim of sodomy, tossed onto the compost pile of somebody's garden. Would I have cared if I had grown up in Santa María? After all, he was just one faggot more.

But back to Rinaldi. He was a family man, forever professing the deep love he had for his six children—and I suppose his wife, too, although I don't remember him mentioning her much. I met her once or twice, a very quiet woman, mouse-like in her deference to men. She worked as a secretary for a local accountant. The only thing she ever said to me one day, when I bumped into her on the street, was that the letters of the Spanish-language typewriters are in a different order than the letters of the English-language typewriters. "Yes," I replied, "where *do* they put the letter 'Ch'"?

I soon found out Rinaldi also loved other people's children, especially the foreign girls who came on the exchange program to Santa María. He would befriend them, console them when they began to miss their parents, and, to help them adjust to this new and challenging environment, he'd screw them. He was a charismatic man, a stereotypical "Latin lover", if there is such a thing. Everyone in town knew of Rinaldi's extra-marital affairs. Whenever his wife wasn't around, men honored him with sly looks and a friendly elbowing in the ribs. How manly it was to have half a dozen children from the same woman and then seduce all the

exotic young girls on the side! He was a man of distinction, a man of excellence.

The prize for that summer was a 15-year-old girl from Poland, and if Rinaldi was the stereotypical Latin lover, then she was the textbook Teutonic princess: severely short, flaxen hair, steel-rimmed glasses and a penetrating look. I don't remember her ever smiling, except the day I left. (She hated me, for some reason, and I was never too keen on her, myself.) If I hadn't seen her sharing a sleeping bag with Rinaldi during a cold camp-out sponsored by our school, then I wouldn't have thought her capable of any sort of passion. Then again, I suppose Rinaldi's forte was bringing out passion in young girls.

That same night, just before he wrapped himself in the warmth of his new conquest, Rinaldi chased Nati around the cabin, drunk as he was, and Nati had searched for me outside, her dark, haunted eyes full of misery. We stood side by side, untouching, in the cold, and watched the snow fall. It was the first time Nati had ever seen snow. She said it was beautiful.

We looked out at the cold night together, while Rinaldi swayed drunkenly to the sound of John Denver, droning on some battered cassette player indoors.

Chapter Seven

Literary Deconstruction

What Rinaldi loved most—perhaps even more than preying on lonely school girls—was 20th century American literature. His favorite, beyond comparison, was Ernest Hemingway. I, myself, didn't read any Hemingway until I was eighteen, even though my mother had his entire collection at home. As a young writer, I considered myself a noble savage, untouched by modern literary convention. My thinking was that, if I stayed away from the likes of Hemingway, Camus, Hesse, and all the other gods long enough, I would develop my own style without fear of infection, without basing my art on the wax rubbings of the masters' grave stones.

But, as I said, Rinaldi loved Hemingway. Looking back, that's probably another reason why I stayed away from Hemingway as long as I did. Anything with Rinaldi's stamp of approval was something I definitely wanted to avoid.

It's strange, but despite my disliking Rinaldi so much, we spent an awful lot of time together. I suppose we were the only men in the village who didn't care if anyone thought we were gay. Me, because I didn't give a shit. Rinaldi, because he'd slept with so many girls, he had enough heterosexual credit to last a lifetime.

School was a waste of time. For some reason I still can't understand, I was only assigned to mathematics and science classes, which was a nightmare for anyone as un-scientific and innumerate as I am. And they were in Spanish to boot. So, as the teacher spoke, I nodded and wrote short stories in the back of the class.

I had no room in my mind for math, for I was a jumble of teenage anguish. Rilke-like, I dreamed of becoming a famous novelist or poet after having suffered, of course, my proper quota of loss and despair. Rinaldi took a great interest in my stories. It was, as I should have suspected from the outset, an interest derived out of self-interest. He wanted me to give him one of my stories, so he could "correct" it and enter it in a local contest under his name. For he, too, was an aspiring fiction writer.

In my best tragic-hero tone, I told him "No!", telling myself I'd rather have my story burned than have it published under Rinaldi's name.

My tirade was an outgrowth of my new-found independence, as was my conviction that I shouldn't contact my parents the whole summer. Living in that repressive, little village was horrible, but it was my experience,

and, for it to be truly mine, I had to live it and suffer it alone. If I leaned on my parents, how would I really know whether I could rely on myself?

About a month into my exchange program, I received a postcard from my mother—it was from the Paul Klee exhibit that had just arrived to Cleveland. "Ugh, cubists," I thought. (I was going through my classical phase at the time.) Mom was extremely worried about me. Besides the fact that her youngest child was lost somewhere in the Patagonia, she had seen something disturbing on the nightly news. In Buenos Aires, someone had broken into the crypt of former dictator, Juan Domingo Perón, severed the hands off the corpse, and stolen them. According to my mother's account, there had been rioting in Buenos Aires, overturned garbage burning in the streets, clashes with the police. I had read about it in the newspaper, too, but if there ever were troubles in Buenos Aires, nothing at all—characteristically—happened in Santa María.

Perón's hands became a topic of jokes. I, myself, once said that not only did the Peronist party not have a leg to stand on, but now they couldn't even do handstands. (I think it sounded better in Spanish.) There was certainly garbage in the streets—as there had been before Perón's hands went missing—but no fires, no tussles with the police.

My mother also wrote that two poems I had submitted to an anthology had been accepted. I was elated! Was this my moment? Had I, perhaps, suffered enough? I would show this to Rinaldi. I would throw it in his face. Unfortunately, she then continued, there was a fee for acceptance. It was then I realized that what I had thought was a contest was, in fact, a ploy from a vanity press, a promise to print anyone's garbage for ten dollars a pop.

Therefore, I resolved to break my monkish vow of silence. The antiquated Argentine phone system was prohibitively expensive, so I couldn't call home. The mail clerks in Santa María frequently steamed stamps off envelopes to resell them, so sending a letter wouldn't do. Instead, I went to the post office with Nati, and she helped me send a telegram home. It consisted of ten words: "Am Safe. Hands Fine. Fuck Editors. Love Argentina. Love You." (The telegram cost me my last twenty dollars—ten dollars more than it would have taken me to get published, which pleased my overabundant sense of adolescent irony.)

As Rinaldi and I were returning home from school one day along the dusty roads of the village, he told me about his favorite Hemingway story, "A Clean, Well-Lighted Place". Rinaldi believed the story captured the essence of Latin American nihilism. As the old man sits in the cafe, calling for another saucer of wine, the old waiter repeats his creed:

> It was all a nothing and a man was nothing too.
> It was only that and light was all it needed and a certain cleanness and order. Some lived in it and never felt it but he knew it all was nada y pues nada y nade y pues

nada. Our nada who art in nada, nada be thy name thy kingdom nada thy will be nada in nada as it is in nada. . . .[5]

That was Rinaldi's creed as well. Fidelity was a joke to him, whether to God or to his wife. His country meant maybe even less. He eventually made a go at running away with the Polish girl—although it finally didn't pan out—in order to get a passport out of the dust and drag of Santa María. As for his children, it was difficult to know what he felt, although he assured me he was capable of doing anything to protect them.

Chapter Eight

Self-Defense

As I walked down the dark streets to my going-away party that night, I felt in the pockets of my leather jacket for the knives I carried there. In my left, a black-handled switchblade. In my right, a red-handled stiletto. I'd been told it wasn't safe to walk the streets at night. (Safety, that was the reason my host parents gave for wanting me to hang around with that twisted, son-of-a-bitch "brother" of mine, Esteban.) The knives' blades were unsharpened, but the tips were pointy. If I used them, I'd have to stick them straight through, driving in the dull blade—something I was not looking forward to at all.

Funnily enough, as I walked down the street, the lyrics of an old Johnny Cash song my father used to play, "Don't take your guns to town, son", floated inside my head. My father always told me if I carried a weapon, I had to be prepared to use it—"If you shoot, shoot to kill". I agreed with him, but I wondered if I'd have the courage to use my knives. I just hoped I'd never have to decide.

One night, I came pretty close, when the village drunk accosted me. (Santa María was small enough to have just one village whore, one village faggot and one village drunk.) I had previously made his acquaintance while walking with a South Asian friend of mine from the exchange program. The man followed us for several blocks after school, rambling on about how Cassius Clay was the best boxer in the world. (He had obviously mistaken my Indian friend for "*un negro*" and was trying to pay a compliment to his race.)

The next time I ran into the drunk, I was alone, and he was in a foul mood. He shouted at me that the United States was a country full of imperialists, and something semi-intelligible about how we had helped slaughter the poor boys from Santa María in the Falkland Islands War, a topic that was wearing quite thin with me, given my expulsion from school. Then he gesticulated wildly, attacking the air with an imaginary rifle fixed with a bayonet, and shouting that he hadn't wanted to offend me. After all, he admired the U.S. military, we had the best army in the world, and then something incomprehensible about Vietnam. He began firing some imaginary sub-machine gun, spraying me with saliva-filled volleys— "*duh-duh-duh*".

Then he lurched at me, and I grabbed the red and black handles of my knives tightly. It shot through my mind how I'd only be able to use the stiletto, because it was too difficult to open the switch-blade, palm

out, and then stick it in his stomach. But then he did the most amazing thing: he grabbed me by the shoulders and kissed me behind my left ear.

I shook him off, disgusted, smelling his hot breath and oily hair on my cheek. He slunk back, his energy dissipated from the attack. It was confusing, surreal. I began to back away quickly, casting a look at him every once in a while, as I retreated through side streets, hoping he wouldn't follow me home. As I got further away, my fear drained away and was replaced by anger.

First his pseudo-attack bothered me. Then the fact that he kissed me, something no other man had ever done, except my own father, and only when I was very young.

Now it seems ridiculous I ever contemplated sticking that frail, old man with my dull knives. However, as I hurried back home, I was not in a conciliatory mood. Feeling angry and a bit homophobic, I considered going back and kicking the shit out of him. At the time, it seemed like a good compromise between letting him get away with kissing me and killing him.

On the way to my going-away party, I stopped at an empty street corner, letting a lone Ford Falcon pass. I noticed red graffiti spray-painted on a wall that said "OSVALDO—ASESINO DEL PUEBLO"— murderer of the people. I didn't know who Osvaldo was.

Later, at the party, as we passed the plates of *empanadas* back and forth across the table, I casually asked Nati who Osvaldo was. She said he'd been the military commander of the area during the Dirty War. It was under his leadership that many of the military's atrocities were carried out. Whole families were taken away, never to be seen again.

Rinaldi interrupted, saying the Dirty War was a *war*, after all, and people die in wars. I said, as well as I could in my broken Spanish, that I'd heard the military had used torture, and that had nothing to do with fighting a war. Moreover, they had tortured children— to death. Rinaldi dismissed my protest with a wave of his *empanada*.

Then Rinaldi told me the following story. Before the military dictatorship, one of his many children had come down with the flu. Medicine was expensive and so was the stay in the hospital, so much so that Rinaldi used up all his savings, and even that wasn't enough. He then had had to go to the hospital and sell his blood to pay the rest. "My own blood," Rinaldi said, "for God's sake."

On the other hand, when another of his children fell down and broke his arm, this time during the dictatorship, everything was paid for by the military. The X-rays. The cast. The hospital bed. And it was Osvaldo who had ordered the hospital to be built, along with the local parks, schools and soccer fields.

I said, (or, rather, tried to say, because my Spanish was so poor) "*Porque otra gente pagó con su sangre.*" ("Because other people paid with their blood.")

The Pear Tree: Is Torture Ever Justified? / Eric Stener Carlson

Rinaldi looked at me from across the table, his dark eyes shining in the candles that Don Amado had set for us. His black hair was slicked back, his teeth were bright. "Imagine," he said, "that a terrorist has placed a bomb in your child's school and you don't know where it is, and you don't know when it's going to explode. And imagine you've got a suspect tied to a chair. You know what I'd do? I'd take every tooth out of his head with a pair of pliers until he told me where the bomb was."

I looked into Nati's dark, oval eyes, and asked her how to say "*Y si estás equivocado*?" ("And if you're mistaken?") What if the man you've just mutilated isn't a terrorist, after all?

Rinaldi put half a meat pie back onto the platter, because he had expected chicken and had gotten spicy beef instead, and shrugged, "Well, after all, it is a war."

I was disgusted with Rinaldi, and with myself as well. I had eaten too many *empanadas*. I had stayed up too late, and I had to catch the bus early the next morning for the long trip back to Buenos Aires.

But perhaps I was disgusted most of all with the comparison I began to form between Foster—my father's friend who had saved me from the Stranger—and Rinaldi. I was beginning to see how things like this worked. Degrade the homosexual, because you are secretly a homosexual. Torture a man, because he *may* have kidnapped your child. Kill a man, because he *may* be planning to kill your child. (I thought back to the drunk I'd considered sticking with my dull-edged knives.)

Rinaldi, the philanderer. Rinaldi, the complete bastard. And yet, somewhere under his shiny hair, somewhere behind his gleaming teeth, he felt an attachment for his children, so much so he was willing to risk torturing an innocent man to save them. I can't call that love, but it often passes for love, the same profound separation between the lives of family members and the lives of Strangers that the residents of St. Hugh made half a world away.

That cold, summer night, I walked back to my host family's house to pack my bags, innocent of Hemingway, innocent of the ways of torture. I kissed Nati on the cheek before I left. I kissed Don Amado on the cheek as well, thanking him profoundly for the party. Then I shook Rinaldi's hand, looking into the bright, shiny eyes that I hated so much, and said goodnight.

Chapter Nine

Thirst

Thinking of my last night in Santa María, I looked up at the bright stars, absent-mindedly searching for the Southern Cross. But I knew it wasn't there. That had been another night, another hemisphere. Several years had gone by since I'd said goodbye to Nati, and I still hadn't found my way home.

I was in the village of El Roble, which means "The Oak Tree", something I could never understand, because there were no oaks or acorns or the hint of either anywhere around. There were only a few palms strewn about the landscape, amid the rotting grass and dust.

El Roble was a small accumulation of huts on the island of Española, smoldering somewhere, forgotten, between Cuba and Puerto Rico in the Caribbean Sea. It lay on the Dominican side of the Haitian/Dominican border, marked by a line of raggedy trees and a couple of undernourished soldiers with machine-guns anxious for bribes, a kilometer or so away. I imagine El Roble looks the same today, if the dust and the heat haven't swallowed it up.

That night, I could hear the drums of the *macumba* ritual not far off, the muffled chanting of voices I couldn't understand projecting up from the valley. The family I was living with told me someone had died in the village recently. At least, that was the gist of it. By this time, I could speak Spanish fairly fluently, but, as it turned out, the family of poor peasants I was living with spoke the language worse than I, in a peculiarly-contracted, grammatically-troubled Dominican border dialect.

As I partially understood, the people in the valley down below were saying goodbye to *el muerto* with drums and rum and much tobacco smoking. Their goal was to enter a possessed, drunken state, to guide the spirit on its journey.

I was brushing my teeth. I can still taste the bitter iodine in my mouth from the water I poured through my "Camper's Collapsible, 100 Percent Reusable, Portable Charcoal Filter–GUARANTEED". It was not the drums, but the heat and the heavy air that had driven me out of bed. I was dizzy. My thoughts were incoherent. I don't remember actually having fallen asleep, but I had dreamt of water again, that's for sure.

I had written in my journal a few nights before,

> If I die from a stomach infection, you can be pretty sure
> it was from the milk I drank tonight. It was warm, and I

hope boiled. I really was thirsty today, and I remember from Scouts that you need to drink when you feel like it, so I finished the second bottle of water. I only have one left. . . . I think I can survive on Coca-Cola, but the nearest town's so far away.

Even after midnight, the heat was painful, and my throat was terribly dry. Nonetheless, I couldn't drink the water. I retched and spat it on the dry ground.

Just out of reach, there was an ever-present chimera of waterfalls in my mind. I thought back to the development specialist who had set up this week-long home-stay for me. He had said it would add to my "cultural experience" of studying for a semester in the capital city of Santo Domingo. However, the more time I spent in El Roble, the more I felt an increasing nostalgia for Santo Domingo's poverty, filth and misery.

The robust man, with his robust mustache and Guayabera shirt, seemed to have leapt off the cover of some dog-eared Wilbur Smith novel. He had proudly told me that he, and a group of like-minded volunteers, had built El Roble's water filtration system. He quickly hastened to add, however, that it didn't exactly filter out *all* of the bacteria it was supposed to.

The villagers, of course, could drink it and be perfectly fine, because they were accustomed to consuming much worse than that. But if *I* were to drink the water, I would be at risk of contracting typhus, amebic dysentery, and whatever else might have been throbbing through the unsanitary tubing of the "filter".

Despite this warning, and even before he finished my orientation session, he encouraged me to drink the water anyway. If I didn't, the villagers would begin to doubt the quality of the water system. From there, they would go on to doubt the vision of its builders, and, as a result, it would be extremely difficult to enlist the villagers' help for the next poorly-planned and badly-executed development program. He ended his monologue to me with some cliché like "Community involvement is a must."

Dizzy from dehydration after having lived in the El Roble "community" for four days, I tantalized myself by pouring a few drops of polluted water over the nape of my neck. If I couldn't drink it, then at least I could cool myself off with it. My mind dawdled on the empty bottles of mineral water lying useless in my duffel bag, and I dreamily contemplated—should I survive and meet that smiling son-of-a-bitch again—how I would punch him in the nose.

Chapter Ten

The Petting Zoo

I shared the small, concrete shack (about fifteen feet by twenty-five, covered by a tin roof) with a family that consisted of six to nine people. The exact number depended on the hour of the day and the day of the week. I never understood which were the children of whom—who were the cousins and who the brothers—all of them sleeping in the one house, spanning the ages from two to sixteen. One little eight-year-old girl, however, seemed to be the boss of the house.

She managed everything. She took care of the baby, and usually had a terribly serious frown. She chased away her brothers with sticks when she didn't like what they were doing. It took me a long time to figure out who the mother of the family was—*she* had a younger-looking face than the little girl.

The family had graciously given me a whole "room" to myself, one of the three sections of the shack partitioned off by a thin curtain. I shared it with a chicken and a rat I could hear burrowing under the many bags of seed surrounding my cot. I think the room usually housed three or four family members, and I was touched by the kindness they had shown by giving the entire room to me.

One day, I stood on the small rise of land right behind the shack, trying to find some way of passing the time. The father and the seven- and eight-year-old boys were hoeing their patch of peanut field a few kilometers off.

The day before, I had accompanied them to work, offering to help. I tried to hoe, but I had no idea what I was doing and killed two peanut bushes. I was horrified. As I wrote in my journal,

> This isn't a game here. It's work, life, death. The more I did, the less they did, the more time they'd have to spend cleaning up after me. So I didn't feel bad at all taking pictures [of them] and sitting in a mango tree.

The next day, I stayed back at the house. To escape my boredom and thirst, I decided to pet the small donkey that was tied near the outhouse. I've always loved animals. Growing up, we had so many dogs, hamsters, guinea pigs, iguanas. Our pony, Buckshot. Our wallaby that my father had rescued from its mother's pouch after a group of farmers had hunted the mother down and killed her. (We called him

"Roo" after the baby kangaroo from *Winnie the Pooh*.) Our parents taught us to take care of animals. To love them was our responsibility.

One of my earliest memories, from when I was three years old, was when my mother woke me up late at night and took me down to the basement where our black lab, Mitsy, had just given birth. I was amazed, happy, excited. So many puppies. So many wet, shiny, pretty puppies! I remember one in particular whose umbilical cord had been cut too close to the skin. To stop the bleeding, the vet had pinned the wound closed with a yellow clothespin. The puppy was trying to move around, wobbling, stumbling, with that big, yellow clip gripping it. After all these years, I'm still dazzled by the memory of that bright, yellow clothespin. More amazing than any sunflower by Van Gogh.

One of the many small girls in the shack was taking care of the naked baby. He had a distended stomach and a large knotted belly button, like something a child would tie. She came over the rise towards me and the donkey, with a quizzical expression on her face. She had been scooping up the baby's defecation in the dirt with a discarded license plate and wiping it on the grass. She asked me why I was petting the donkey. I replied, "I love animals. Petting the donkey makes me happy."

Besides, I said, it made the animal feel better too, because he'd been tied down under the sun all day. He'd eaten all the thin, yellow grass down to the ground, seizing every root within reach of his tether. At my response, she looked at me with an even more peculiarly puzzled, screwed-up expression, and laughed.

While I was thinking of it, I went inside the shack for the half-filled box of raisins I'd stowed inside my backpack. I hadn't finished them, because eating them only made me thirstier. I poured the raisins onto my hand, sticky, ants crawling through them, and offered them to the donkey. The little girl asked what I was doing. I said, "Trying to feed the donkey. He looks hungry and sad."

The little girl laughed at me again, and said, "Donkeys don't eat raisins". The donkey, meanwhile, snuffled at the raisins, its mouth foaming, wetting the few dried flecks of grass pasted to his whiskers. Then he stretched out a dry tongue and began eating them. The girl shrieked with pleasure, apparently never having seen anything more amazing than that.

Just as I thought I was making my point, the little girl, still laughing, struck the donkey with her open palm. Then she struck it again, hard. The donkey winced and pulled away from my hand. He dropped the few raisins he had been collecting in the dry groove of his tongue.

I asked her why she'd hit the donkey. She replied, with a smile, "Donkeys don't feel anything". To emphasize her point, she struck the donkey several times more, jerking its ears and twisting them about.

The Pear Tree: Is Torture Ever Justified? / Eric Stener Carlson

The donkey hee-hawed and tried to pull away but found it could only go as far as the rope allowed. The girl's younger sister got up, and, mimicking the first child, began to beat the donkey, too. The rope was now twisted tightly around the stake, and the donkey could hardly move, its knees turning inward.

For a moment, I thought of stopping her, shaking her, slapping her, telling her what a bad, monstrous little girl she was. But I didn't. Of course, I didn't. I just slowly walked back, to find shelter in the shade of the house. That was the way things were in El Roble. That's the way things were, for the most part, in the entire Dominican Republic.

I glanced at the donkey, with its large, stupid eyes, and then to the pale brown dog with the broken leg. It lay in the shade next to me, trying to keep out of the bleaching sun. As I wrote later,

> I don't feel anything, and that scares me. Because [the children] are not part of my society, I don't want to change them. . . . If they want to walk around naked, who cares?

My only preoccupation was water and the menace of infection that drinking it posed for me.

I watched how the dog's leg dangled as her chest inflated and deflated with each frantic pant. ("'Regard the bitch dog', the lamppost said.") One of the children had hit her on the leg with a rock. For fun. For a moment, I thought of reaching over and breaking the dog's neck out of pity. Instead, I asked the little girl what the dog's name was. My voice floated, pathetic and small, through the hot air. She laughed and ran away.

Of course, the dog didn't have a name. They called it "*el perro*"— literally, "the dog." They called the dog, "the dog", the cat, "the cat", the pig, "the pig". The chicken, too, was simply "the chicken". One of the many boys told me this one day, as he cracked the bones in the chicken's flapping wings between his strong, nimble fingers, making it squawk and scratch the air. For fun.

Only animals with a specific purpose, like their ox, had names. This is so it will listen when you crack the whip and call its name, telling it to go right or left. And it does go right or left, because, being named and being conscious of its name, it knows unresponsiveness will be punished.

I once read a book by a Dominican psychiatrist who wrote that mistreatment of animals was endemic there, and it derived from the overall mold of repression in that ever-declining half-island nation. What I was witnessing was the tail end of a larger process: Man can't find job in big city, goes back to village. Gets drunk, beats wife. Wife beats oldest daughter who's been lounging in the shade (who reminds her, by the way, of her husband's favorite "wife", whom he visits far too frequently in

town—That whore!). Oldest daughter beats younger brother, taking advantage of the few years before his biceps develop and he can beat back. And so on and so on, down the gauntlet, until the youngest boy, only two, can find no one else to beat except the donkey. And then, not finding enough satisfaction in that act of cruelty, he beats the dog, a dog who is not a "who" but a "what", an "it" that lies in the shade, useless because it does not have a purpose, an easy target for a stick or a small rock thrown.

This author noted that all serial killers in the U.S. have, somewhere in their childhood, tortured animals. Therefore, he posed the question, "Since animal abuse is so widespread in the Dominican Republic, are we an island of psychopaths?" The thought was too horrific, unacceptable. But, as I tried to find some shelter from the sun and from the children abusing their animals, I muttered as much under my breath, ready to write off the whole culture as one frenetic *merengue* tune of a satanic mass.

Yet I know the reverse isn't true—that people who care deeply for animals would never harm a human being. (Hitler's love of dogs is almost proverbial.) But when I saw the way beasts of burden were treated in the streets of El Roble—the oozing ulcers on the backs of feeble horses where the leather scraped them incessantly, the unhealing gashes where the rider's whip lacerated again and again, not for reasons of speed, but, like the rose thorns in *The Little Prince*, just out of spite—I wondered, once you've done this to an animal, how easy would it be to do the same thing to a human being?

I'm not talking about killing an animal for its meat or its skin or to make soup out of its bones. I'm not talking of killing for its own sake, to hang some gnarly, dried horns as trophies on the wall. And, as horrible as it is, I'm not even talking about executing a row of ten men tied to posts, so you can get laid in the officers' brothel afterwards. I'm talking about the perpetuation of agony for pleasure's sake, for fun—like the children did. That's the most appalling part.

Thinking of rewards, I imagined the children I was living with would have ascended superbly through the military ranks, had they been called upon to apply their torture methods to people during the Trujillo dictatorship. The topic of my independent thesis while on the island was Rafael Leónidas Trujillo's reign of terror from 1930 to 1961, something I studied rather in depth, when I wasn't otherwise preoccupied with staying hydrated.

Enjoying firm support from the United States, Trujillo had established torture centers throughout the country. I interviewed dozens of men and women who had passed through Trujillo's torture centers. (I also interviewed people who had passed by them quickly at night, mumbling the rosary to themselves, trying to shut out the screams.) They churned out a wide range of victims, because Trujillo considered just

about everyone to be an enemy: Communists, school teachers, peasants, bourgeoisie, children—of course, children—and also various factions within the military itself as the dictatorship's partners turned on themselves.

One afternoon, back in Santa Domingo, I visited the remains of La Cuarenta, one of the most notorious torture centers in the Caribbean. I wanted to get an idea of what it looked like *in situ*—the neighborhood, the surroundings. It didn't give an impression of anything out of the ordinary: the plain-looking, stone-faced building had long since been converted into a church. An acquaintance of mine from a local human rights group showed me the blueprints for a memorial they were hoping to construct one day, with shrubbery and a small, commemorative plaza next door. Like most dreams in the Dominican Republic, it stayed on paper. All that encircled the building when I was there was a pile of rubble and half-burned-out houses with suspicious faces peering through barred windows.

I don't know if it was an attempt at exorcism, but, to me, it seemed like some idiot's idea of a joke: there was a large mural on the outside wall that read "*Cristo Salva*". ("Christ Saves.") Behind the metal-grated door, in the inner sanctum basement of the church, were murals along the walls. The most prominent of all was the sacred heart of Christ, excised and bleeding, encircled by a crown of thorns.

I tried to locate the patio where one frail, old man I'd interviewed had told me soldiers set wild dogs on him to chew off his testicles. (I suppose those dogs had names, because they were trained for this specific purpose.) It was also where soldiers raped men and women, which was becoming a rather common theme to me. But the soldiers in La Cuarenta had shown some creativity by tending an anthill on the patio, over which they tied their victims, as if in homage to a 1950s wild western movie.

I looked all around the church, but I couldn't find a trace of the pain of the past. No blood stains, certainly no anthill, remained. It was just a big, dark basement full of empty folding chairs with the heart of Jesus, as big as a sack of Idaho potatoes, painted like some gaudy Hallmark™ greeting on the wall.

Chapter Eleven

Elocution

Under the banner of "Anti-communism", Trujillo brutalized the Dominican population for over thirty years. The United States supported him in this, shoring up his regime with the threat of an invasion, should he fail. (As FDR's Secretary of State, Cordell Hull, is supposed to have said of Trujillo, "He may be a son-of-a-bitch, but he is our son-of-a-bitch".) But I can't say Trujillo's was really an ideological mission. It was more personal, privately brutal. Perhaps the U.S. supported Trujillo to avoid another Cuba, but what *he* wanted was just to maintain control of his private, Caribbean fiefdom, to exercise his every whim.

Doctrine was not the dynamo for torture on the island. If Trujillo objected to the way a disc jockey's voice sounded on the radio, then his men killed him. If Trujillo's men wanted to have sex with a young girl, then they kidnapped her. They'd rape her, and most likely kill her. If she were "lucky", then they tossed her by the side of the road to find her way back home in the darkness, ripped and bleeding. Trujillo could have said "*L'état c'est moi*", except for the fact he did not rule over a state in the technical sense, but rather a loose confederation of slums, clandestine jails, and sugar-cane fields, all of which was at his personal disposal. Armed bands ruled the country, killing and torturing at random.

Even during my stay in the late 1980s—under "democracy"—I was told by my Dominican friends to steer clear of the "triumvirate", a group formed of Army, Police and Special Forces, that cruised the streets in military vehicles. If they decided to pick on you, then your number was up. There was no FBI, no higher court to turn to. They were the law, or at least the force no Dominican law would stop.

When I was there, Dominican society was still divided and subdivided into power groups—even the fire department was controlled by a hierarchy, from General on down—and God help you if you weren't in uniform. God help you, anyway.

In a place like that, it's you and your gang versus the rest of them. The fabric of your uniform, those patches on your sleeve, are the only things that protect you. Far from its stereotype of a means of gathering information, torture becomes a method of self-assertion, domination for your group. It demonstrates your power in an uncertain time, when the Stranger threatens to rise up against you. Once the notion of a Stranger is established—a Stranger who is to be feared, who cannot be given rights—a state of constant, bloody anarchy emerges.

The most terrifying vignette of Trujillo's dictatorship came in 1937 when Trujillo ordered all Haitians to leave "his side" of the island in twenty-four hours. This was yet another abuse in a long list of abuses suffered by the Haitians, who were victims of political repression back in their own country and economically exploited in Dominican Republic as virtually slave labor. (Of course, Trujillo's order was impossible to comply with, like asking for an orderly evacuation of Washington, DC, in the face of an imminent nuclear attack.)

The Haitians, being Patois speakers, have a quasi-French accent, and many of them cannot pronounce certain Spanish words "correctly", as the Dominicans say. There is one word in particular, "*perejil*" (meaning "parsley") that is difficult for them to say. Therefore, to root them out, Dominican soldiers stopped all "dark-skinned" people throughout the country and forced them to say "parsley". Those who failed this pronunciation test were murdered on the spot. (Some estimates range upwards of 20,000 dead.)

What my stay in Dominican Republic taught me was that "the Stranger" is a much more ample category than the child-killer, as in St. Hugh, or the subversive, as in Argentina. He (or she) is the one whose skin is a shade darker than your own. He is the one on whom you concentrate all your fears. Then there's nothing more to his humanity than the way one single word rolls off his tongue—not his face, not his intellect, not his soul, not the quality of his thoughts. Then, the only obstacle between him and the machete is that little herb. "You say tomato and I say. . ."

What troubled me about this particular mass murder, beyond its brutality, is that Dominicans and Haitians really do look a lot alike, especially those living on the border. Anthropologist friends of mine tell me there's been so much inter-marriage, such cultural fusion, that it's impossible to distinguish what is "purely" Haitian from what is "purely" Dominican. And yet, in the Dominican Republic, you still hear such expressions as "bad" hair (meaning African hair), "bad" lips (meaning African lips), and the ever-present "too dark". "*Haitiano*" is not so much used as a nationality, as it is a euphemism for shit. And "*perejil*" is still used as a test by Dominican soldiers as they round up Haitians and put them into forced labor camps during *zafra*, when they can't find enough Dominican hands to cut the sugar cane.

Even in one of the poorest nations of the Western Hemisphere, people feel they must make differences. No matter how poor you are, there has to be someone poorer. No matter how dark you are, there has to be someone darker. Slowly we whittle away our similarities until we are left on our own private island, surrounded by enemies.

When Trujillo was assassinated by his former comrades in 1961, they carried on where he left off. Except for a momentary repositioning of who was on top, who was on bottom, who held the cattle prod, and

who was sodomized by it, nothing much was accomplished by this "transition to democracy". This period of violence was appropriately called the *machetazo*, named for the cutting of the grass with machetes, something you still see Haitians being forced to do in Dominican Republic. Stripped to the waist, sweating out their lives under the sweltering sun.

After what I'd learned in the Caribbean, I began to wonder about the nature of obedience. Most of Trujillo's torturers, as I've been told, didn't "like" torturing. They were "just following orders". Did that make them better, or worse, than Roberts, who was probably listening to the orders in his head? From Neptune, or Satan, or his dog.

You see, I'm not as bothered by the psychopaths—those who show a complete and unrelenting disregard for human life. What concerns me more are the men and women who hold some lives in high regard and yet despise others. They know it's wrong to torture and yet, they obey the order to do so anyway. They separate the pronouncers of parsley from the mispronouncers, the blacks from the whites, the Aryans from the Semites, the Hutus from the Tutsis, the Armenians from the Turks, the Muslims from the Christians. The *hypocrisy* of the Eichmanns, those faithful, panting corporals, disgusts me more than the *delusions* of the mentally ill.

That night in El Roble, with the drums in my ears, I looked up at the stars, and they struck me as being the clearest, most beautiful I'd seen in my entire life. They filled the sky, a mass of points, so bright and attractive. No one constellation could be seen, all of them mixing together. No electric lights for miles to dim their incandescence. At the time, I wrote:

> I never remembered seeing them twinkle before. I mean, *really* twinkle. Then, as sometimes happens to me, everything seemed to have a place in the world, every twig, every animal, every person, everything was a part of it all. Then I thought, "This is life itself."

I reached out to the stars, thirsty, dizzy with the heavy air, ridiculous on my tip-toes, as the voodoo drums played far away. For some reason, I felt compelled to say aloud, "This must be the face of God."

But my words were the hypnotist's fingers, waking up the volunteer from the audience with a "snap". In that moment, I completely— and terrifyingly— disbelieved. I doubted. I doubted God. I doubted decency, morality, everything. I couldn't see the beauty of the stars any more but only the great, empty, looming spaces between them.

In El Roble, there was no law. There was no moral system. In this kingdom of rotting cilantro and shit, set amongst the little vegetation that hadn't been obliterated by machete stroke after machete stroke, or

burned away to make room for more peanut plants or water filters that didn't work, the only order was the pecking order. That, and death.

Without some *other* kind of order, religious or political, there was no reason to shoo away the sleeping dog before the baby's small, clutching hand could twist its broken, dangling foot. For fun.

There was no hypocrisy in this great, grinding machine that unwound under the hot sun, because no one pretended to be anything but vindictive and cruel. And I had been mistaken to think there was no equality, for there was equality in the lack of value that was attached to everything. The life of anyone—brother, chicken, sister, dog—had no particular worth, other than that some stranger, like myself, had imagined to exist. That imagination came from not having had to scratch the earth twelve hours a day with a medieval hoe, from not having felt the need to cut somebody's throat, to steal and gulp down his last half liter of filthy, tepid water.

Mistreat anyone whom you have the power to mistreat. This rule had a certain simplicity, a stark beauty, in fact, as I thought deeply towards the abyss of it.

I thought back to Hemingway's old waiter and wondered if he wasn't right after all. I tried to say the Lord's prayer, but only Rinaldi's empty creed came to my chapped lips. I muttered the words, "Our Father, who art in nada, nada be thy name, thy nada, nada. . . . forever and ever." And that was all.

Chapter Twelve

Primary Sources

Bending over the open grave, I plucked one metatarsal carefully from the skeleton's foot where it had lain for almost twenty years, outlined in the thick, dark mud. I placed the bone in a soggy cardboard box, and turned up the collar of my coat, because it had begun to rain again.

It was the early 1990s, and I was in Buenos Aires volunteering with a group of forensic anthropologists. I was spending the vacation between my junior and senior year at American University on my hands and knees in what had once been a clandestine grave for the "disappeared".

In the years that had followed my last night in Santa María, I'd promised to return to Argentina. It wasn't for Nati, though. We'd written a few dark, angst-filled letters over the years, never quite saying what we meant. She'd even telephoned me once, but all she could afford was three minutes, and whatever we had ended with the dead dial tone. I wasn't interested in returning to Santa María. That village was as much a hell as El Roble ever was, and I didn't relish the thought of picking up where I'd left off as an awkward teenager so many years before. I came back, because I felt a need to ground myself in the place I will always associate with mass violations of human rights, dictatorships, and death.

My experience in the Dominican Republic had spurred me to study human rights. I'd written my final report on La Cuarenta, for which I got a disgruntling "B". (Was it my punctuation?) I read reports by Human Rights Watch. I even bought an Amnesty International T-shirt with an orange-faced prisoner staring through an iron grate rendered by Picasso. But I felt all along I was merely killing time in the theater lounge of my life, following the slow hands of the clock above the bar, waiting for the main act to begin.

I'd spent too much time reading about massacres or talking to people who had survived them, or talking to my peers about how "All of this is so terribly wrong". The topic of torture was fast becoming hypothetical, text-book clean, and I was becoming detached. Who were the people, the real people, behind the statistics of death? What did those blown-up, grainy photographs of children the Mothers of the Plaza de Mayo carried every Thursday in front of the Casa Rosada mean to me?

And then there were certain South Americans I'd met at college parties every now and then. British-accented children of the land-holding,

fascist elite, wearing plum-colored suits and expensive shoes, would smile at me and consider me a rare bird because I, a *yanqui*, took such quaint interest in *indigenista* things. They assured me there'd never been any disappearances. This was just a lie promulgated by the Leftist Press. "Besides," they would remark, as the parties dragged on, "you Americans did much worse in Vietnam."

I began searching for a way to connect myself to what I'd read in books. There had to be something that bridged those people's pain and my protected, intellectual life. There had to be proof to show those bastards the next time they praised dictatorships over a frothy cappuccino.

One day, I saw a television documentary about a group of anthropologists working in mass graves in Buenos Aires, attempting to identify *los desaparecidos*. I thought this was my chance to get at the core of what it's all about, a chance to break out of my academic stupor. There could be no better proof than seeing the bodies for myself, than holding their bones in my hands.

Through much persistence (and luck), I got the telephone number of Clyde Snow, the great anthropologist and founder of the Argentine Forensic Anthropology Team. I telephoned and telephoned and telephoned him at his Oklahoma home, until he gave in to my request. He agreed that, if I paid my own way down to Buenos Aires, I could work for free in one of the mass graves. So I took a summer course in archaeology at the Cleveland Museum of Natural History and a short course at the Smithsonian Institute in forensic anthropology. I got a part time job as a hotel booking agent, which earned me enough to pay for half my ticket. My father worried I might be getting myself into trouble, entering a dangerous world of terrorists and revolutionaries, but, as always, he supported me, and gave me the rest of the money for my ticket.

During the Dirty War, in the cemetery of Avellaneda—named after one of the great Argentine presidents of the past—the military had bricked off one section where the morgue stood and built their own private entrance to it. It was there they brought the bodies of the recently-executed over a period of several years. Of course, "no one knew" what was going on, like the German peasants in Dachau who were "shocked" to find out what had *really* happened there after liberation. How strange no one seemed to notice the human ashes that floated over the walls for so many years.

We worked out of the same morgue in which the military had performed their sham autopsies. They had written that "Juan Pérez," the man with the small bullet holes in the back of his head and the large exit wounds in his face, "had committed suicide". "Juana García had fallen in the shower", although how she got those rope burns on her wrists and ankles from slipping on the soap, the military doctor never explained. This was what my anthropologist colleagues explained to me. I was just qualified enough to not mix the metacarpals with the metatarsals and to

brush the dust carefully from the skulls. It was for the tried professionals to record the grid locations and to determine the cause of death.

At night or during the day when it was too wet to excavate, I returned to my room in the monks' quarters of a religious high school in downtown Buenos Aires. I stayed for free, because a friend of a friend of mine had arranged it with the "brothers". I was overjoyed, because I had no money. It turned out to be less of a bargain, however, because the place was so filthy and unheated that I almost went blind.

I lived in an uninhabited wing of the school, salon E, room 36. I entered via the long, cold marble hallway, and either took the iron-grated elevator or tramped my way up the stairs to the third floor. The gas heater in the hallway cast a cheery, cherry glow. But as I opened the door to my room, the lighting became dull and supernatural, a mix of something between "The Fall of the House of Usher" and *The Name of the Rose*.

The first thing I'd do was hang up my soggy clothes. (I had completely misjudged the weather and had brought only one coat—not a waterproof one at that—and only two sweaters, condemning myself to a constant damp.) There was a gas heater in the large, gloomy wing, but I couldn't leave it on at night. The "brothers" warned me it was faulty and might leak, killing me in my sleep. I began coughing up phlegm after my first week. Sometimes I went to bed with all my clothes on. Sometimes they were still damp.

I thought I'd never get warm again. Thankfully, I'd remembered reading that Polish immigrant children in Cleveland at the turn of the 19th century would put hot potatoes in their coats to warm them on their way to school. So my nightly ritual was light the gas stove, warm my clothes by the blue flame, marvel at the steam rising from them, and place two or three potatoes on the metal rim. Then, turning off the stove, making sure the gas was tightly off, I'd put the potatoes in a sock, and then bury them deeply under my dirty, llama-wool blankets.

The dust in the high-vaulted rooms was another problem. I coughed and wheezed most of the nights. I tried to wash the place several times, but the walls were so filthy, and the ceilings too, that I kicked up more dust as a result and became sicker still. One morning, I got up at 3:00 a.m., and sat up by the gas stove, cold, feverish, half-blind. As I rocked back and forth, I realized I had found what I was looking for. Here was the reality of the graveyard, and it was killing me.

One day, my eyes were so swollen, I could barely see. One of my anthropologist friends, greatly concerned for my health, sent me in a taxi to the free Catholic eye clinic. When I arrived, the security guard ushered me ahead of the long line of indigent, dark-skinned patients—because I was American, I was important.

Half-blind, I sat down in an old surgical chair. Above me, suspended by wires, inclining only a few meters from my face, was a

Damoclean version of the crucified Christ. I wondered if the look of agony on His face would be the last thing I'd ever see. Luckily, the doctors gave me medication, and my eyes recovered. Thank God for them, or I would have lost my sight for sure.

Sometimes, at night, if it wasn't raining—which was infrequent—I'd escape the dust and cold of my room. After locking the many doors of the monastery behind me, I'd walk up and down Santa Fe Avenue, peering in shop windows. Sometimes, if I had some money in my pocket, I'd spend most of the night in one of my two favorite cafes, "La Farola" or "La Opera". There, I'd make a pot of tea last for hours, suffering the sneers of belligerent waiters, impatient for better-paying customers to replace me.

While sitting in the cafes, I'd feel my irritated eyes with warm fingers and ponder why the Argentine military had produced the corpses I'd excavated that day. One major theme among the soldiers was that their society was on the brink of collapse. Too much corruption, anarchism, homosexuality. Society, they thought, was weak, evil. There had to be "*una mano dura*", a strong hand, to intervene. You had to dispense with the law, circumvent the Constitution (a notion that's presently gaining acceptance in the United States in the war against Islamic terrorists).

The Argentine military had bought into the "lifeboat theory" I was spoonfed at university. Man is greedy. He'll do anything to protect his interests, including pushing women and children out of the *Titanic*'s last dinghy, so that his place, his genetic pool, is secure. Our political and economic position must be maintained, the Argentine military reasoned, and there are only so many seats in the boat.

Most of the Argentine prisoners whose remnants I was digging through had been killed in 1976 and 1977—around the same time Foster had interrogated Roberts in Australia. The Argentine dictatorship was carrying out its interrogations on a much larger scale—with "*la picana*" (bare electric wires); "*el submarino*", (the "wet submarine" was suffocation with a bucket of water, and the "dry submarine" was suffocation with plastic sheeting); and, of course, we can't forget to include rape. As I mention in my introduction, the Argentine military did get rid of the guerrillas with these methods. They also murdered several thousands of non-combatants, which made it effective for the military but ghastly in human terms.

I've often mused about the song "Imagine", but in a different way than John Lennon ever meant it. I imagine, if we took away all the national boundaries, languages and cultural barriers, we'd find many similarities that unite us—but for the bad, not the good.

Take all those who made a business out of genocide in recent times—Hitler, Stalin, Pol Pot, Milosevic, and the rest. Imagine they're really just the same. True, they spout different ideologies. They rouse their nations to murder different kinds of people for different kinds of

reasons. But there is such a similarity in their hatred and in their gift for sniffing out "the Stranger"—the Jew, the Muslim, the Communist, the Bourgeois—the one who's to blame for their society's decline.

But were the Argentine soldiers more like Foster or more like Roberts, I wonder? Were they the policeman overstepping his bounds or the psychopath playing par for the course? Or, perhaps, they were a perfect hybrid between the two, like a Japanese, seedless watermelon. Maybe they were both the Stranger and the Guardian, the rapist of children and the protector of the innocent. Without looking up from their gold-inlaid copies of "The Song of Roland", these glorious defenders of our Western Christian values had made thousands disappear.

Late at night, having dodged the waiters as long as I could, having soaked up the warmth of the café, I returned to my dark monastery. On the way back, the only smiles I got were from the homosexuals who passed me on Santa Fe, dressed in their leather jackets and Armani suits, nodding to me, watching my ass as I passed by in the rain.

Chapter Thirteen

My Mother's Gloves

In order to preserve our sanity in the graveyard, some of us volunteers made jokes of the most revolting kind. Just as, in Chaucer's time, survivors of the Black Death had riotous orgies next to piles of putrid corpses, to remind them they were the living and not the dead, we literally practised "graveyard humor", made puns, carried out pranks. I remember one time I'd just helped unearth a skeleton of a man still wearing a black polyester suit. I held my sharpened trowel as if it were a microphone, saying to my colleagues, "This new Wonder Suit is a miracle. It's guaranteed to last a lifetime. . .and beyond. Look, another satisfied customer."

At the same time, there was no lack of respect for the victim intended in what we said, no denial that what we saw was terrible. Indeed, it was a recognition that what had happened was so grotesque, so unimaginably horrific, that we had the choice of either making fun of it or going completely mad.

It reminds me of one day when I was four and my mother was out shopping. I turned on the television and saw an old movie. There was a beautiful, big house with a family inside. A figure approached. All I could see was his pants, his dark gloves, and the can of gasoline he carried. He douses the house with the gas and sets it on fire. . . . In the next scene I remember, there is a man—the hero, I suppose—breaking into the suspect's trailer. He slowly begins to open one of the drawers and comes across a charred black hand. As he does so, Boris Karloff, I think, appears right behind him and says, in a sinister voice, "Can I help you?"

I was so frightened, so disgusted by the scene that I turned off the television set and hid behind the sofa. For years after that, I was horrified every time I saw my mother's black, leather gloves, because I thought they were the hands charred in the fire. If I went into the closet in our Minnesota home to drag out my mittens, hat, scarf, and coat, and, in all that dragging out, one of my mother's gloves fell on top of me, it felt like the Hand of Death had touched me.

Later, when I was older, I would laugh at these childish fears. But it was the laughter of the graveyard I would come to know so well, a laughter not built out of mirth but meant to cover up the horror of finding myself alone and Death so near. That was what the graveyard was like—finding my mother's black gloves every day. These were the bits

and pieces of horror I'd been searching for, to pull me out of my static existence. Sometimes I wished I'd never left home.

But as the long, soggy days wore on, the graveyard disturbed me less and less. The work became more a bureaucratic routine of 9-to-5. Sorting bones became like sorting letters in a post office. Much of the time, I was as detached as I had been in my archaeology class in Ohio, for a skeleton that's been preserved for ten years looks much the same as one that's been preserved for a thousand.

Of course, I'd note the ribs had been broken before death had occurred, that the arms had been broken too. I'd use my trowel or brush as a size comparison to photograph spent bullets, oxidizing in the ground. I knew what had happened to these people before they'd died, unlike the northern Ohio Indians who disappeared around the time the settlers came, and yes, that made a difference. But it was a back-of-the-mind difference, one I began to relegate to history. I didn't feel it personally.

I began to make a mental separation in the face of this horror. I "closed doors", as they say, using humor to distance myself from the dead, like a soldier in a firing squad uses his uniform to distance himself from the condemned. You convince yourself you're not the victim, because you're not the one who's tied to the post. If you keep that up long enough, you come to a point where the revulsion is just a dull pain in the back of your head, and you can even tune it out, now and then. That's how I grew to make fun of what I saw in the graveyard.

Except for the children.

I'd been told this would happen by a police officer I'd met at the Smithsonian seminar I'd attended a few months before. He told me you can get used to the most bloody murder scene imaginable. You get used to the autopsies—although the smell always gets to you—but you can never come to terms with the murder of a child. There's something that goes beyond the "normal" revulsion we feel for the death of an adult.

This policeman told me how he'd get up at night, tell his wife he was just trying to shake off insomnia, that he'd try to relax by driving around in the car. Then he would drive to the scene where a child had been murdered recently in his precinct. He would park the car and, with the motor running in the darkness, he would ask himself, "Why, why, why?" Sometimes it would last until the sun came up. Then he'd put the car in gear and go back home and tell his wife he felt a little better, although he didn't.

I never thanked the man for telling me that. I didn't know enough to thank him at the time. Then, in that dank graveyard, we came across the skeleton of a child.

My colleagues just remarked to me one day that, in section x of sub-grid y, they had uncovered—judging by the bone structure—the remains of a child. I never saw her, because I was working in another location, but the idea that part of her was there, scattered beneath us, by

the protectors of our Western Christian values, made me sick inside. And how many disturbed dreams I had after that! One churning, continual mess in the mud and the rain, me in the torture chamber, me torturing.

But however disgusting my dreams were, at the same time, they were strangely comforting. It was comforting to know I could be disgusted, that I could be shocked and horrified, that "International Relations I and II" and "Micro-" and "Macro-economics" and "Political Theory", hadn't sanded away my sense of humanity, although I sometimes felt it was barely there.

Although it's been years since I worked in Avellaneda, whenever I feel myself becoming numb and thinking I've seen it all before, that I've lost the memory of the dead, the graveyard pulls at me, I put on my mother's gloves, and I imagine a face for every skull.

Chapter Fourteen

Strays

Fernanda was one of the "re-appeared".

Suspected of terrorism by the Argentine military during the late 1970s, she'd gone the route of many others, kidnapped and tortured. But she had been *lucky*—her life was spared. They set her free so she could become a living advertisement of what would happen, if you weren't a bit more careful about your politics, your opinions, your friends.

The anthropologists I worked with introduced me to Fernanda, because I was researching what eventually developed into my first book. She'd been a school teacher before her kidnapping, loved Pablo Neruda's poetry, was virulently Leftist, almost violently anti-Pope. She was gray-haired, neurotic, chain-smoking, brilliant.

She also had the foulest mouth I'd ever heard. The obscenities flowed from her constantly! It would be, light a cigarette, "General Videla, that son of a thousand whores", smoke it down, light another, "the great whore that gave birth to that bastard, General Camps", light one more, "That mother-fucking. . . ."

She was also one of the most genuinely kind people I'd met in my entire life. The day I met her, she invited me—a complete stranger—to her house. That night she made me *empanadas*, reminding me of the old days in Santa María—but what quantity! *Empanadas* and large cubes of cheese and sandwiches and *milanesas* and more *empanadas*, and "How thin you are, have some more", and "Do you have a girlfriend?" (she had a young daughter in college about my age), and "What are you doing in Argentina, of all places?" We talked about her kidnapping, and politics and life in general. Later, I wrote of her in my journal:

> Leftist, maybe, but definitely cool. She hates the people who tortured her—make no doubt about that. But she's not blind. She didn't think either Hussein or Castro were great. She's against militancy, right or left, wouldn't cry if all *militares* were all shot in the head.

She interrupted our conversation now and then to tend to the many dogs she'd rescued from the streets. One was a large, black mutt she had locked in the bathroom. Only she could control him, and when I walked in the door, he tried to tear me apart. There were several others, but I remember especially one small, scruffy Shitzu. She was blind and

whimpered constantly from her pillowed, wicker-basket bed. Fernanda had bought special eye-drops for the dog, and brought her food close to her mouth, because she was too weak to get it herself—wrinkled, puffy faced, with the eyes crusted over. Fernanda worried so much about her.

One day, the dog died. Struck by grief, Fernanda blamed herself for failing somehow. She took several days off from work to recover, feeling totally alone. No one, not her daughter, not I, could console her. . . .

In the room where Fernanda had been held, the soldiers had painted a huge swastika on the wall. They ordered her to say "*Heil* Hitler", but she refused. Even as they beat her, she remained silent. They shouted, "Why don't you just say it, you stupid cunt, just to stop us?" She screamed back, "Because I'm not a Nazi, because I don't believe in it. You wouldn't believe me if I did, because that's not what I am."

Fernanda hated the Catholic Church, with a severe, humanistic passion. She couldn't wipe from her mind the stories she'd heard about priests in the military government. The dictatorship promoted the most rabid, anti-Communist chaplains. These would, in turn, justify the soldiers' acts of torture, and even bless them for their cruelty. For Communism was against the Will of God. To torture such deviants was what God wanted, Argentina's version of the *auto da fe*.

Some chaplains even attended torture sessions, urging the kidnap victim to betray his friends, to brand them as terrorists. They prodded the torturers on, justifying their abuse by scripture, such as Matthew, chapter seven, verses 18 - 19:

> A good tree cannot bring forth evil fruit,
> neither can a corrupt tree bring forth good fruit.
> Every tree that bringeth not forth good fruit
> is hewn down, and cast into the fire.

Cut the tree. Dig at its roots. And the fruit will come. I was familiar with that argument by this time.

One day or night—Fernanda didn't know, because she hadn't seen the sky or sunlight for weeks—the soldiers pulled her from her holding cell and took her to a warehouse. There she saw a small, five-year-old girl sitting. Crying. She'd been kidnapped that day along with her mother, who was a suspected terrorist like Fernanda. They were torturing her next door. The soldier had pulled out the first woman he could find to "baby-sit" during the torture session, and that was Fernanda.

The frightened child wanted to know where her *mamá* was. Fernanda told her, "Look, *Mamá's* working. I'm a good friend of hers. She told me to look after you for a while," hoping the little girl wouldn't hear her mother's screams, as she was being raped in the adjacent room. Fernanda stayed with the girl all night. The next day, her captors told Fernanda she was to be freed.

Fernanda asked, "What about this little girl?" They replied, "It's none of your business."

But it *was* her business. Fernanda refused to be released until the girl's relatives came to pick her up. The soldiers couldn't believe what she said, but—what the hell—they let Fernanda stay. No one came that day, so she stayed with the girl until the next day. Still no one came, and still Fernanda stayed. And she kept on staying for another day and another, lying to the girl, telling her that her mother would come back soon, knowing she had, perhaps, given up her one chance for freedom, but loving that girl and that girl's freedom more than her own. Fernanda suspected they would kill the girl if she left; she was too old to be "adopted" by barren military parents, as happened with probably several hundred children of the disappeared.

One of the many horrifying aspects of the Dirty War was that soldiers often tortured prisoners, not for information—which still would have been unacceptable and a gross violation of human rights—but "for their own good." Over and over again, I've heard soldiers repeat this. The problem wasn't the prisoners themselves, but their ideology. The disease of Communism had infected them, and they, the soldiers, were the surgeons of society, cutting out the malignant growth. (This was, perhaps, the most trite of fascist metaphors.)

That's why the military and, to a lesser extent, the police, "adopted" children of the disappeared, because they hadn't become infected yet. If they could raise the children in a decent, nationalist, Catholic home, then they would become model citizens. Perhaps they'd even become the staunchest defenders of the State, the hope perhaps being that, when the day came, they'd torture subversives like their biological parents.

A few days later, the grandparents of the little girl were brought to the torture center, and they took her back home. That same day, Fernanda allowed herself to be released. The soldier in charge said, "You're one strange bitch. Why didn't you just go home?" Fernanda replied. "Because that girl needed me, you stupid son-of-a-bitch."

And so, with her freedom and her remaining years, Fernanda continued her left-wing way of thinking, continued hating the Catholic Church, continued cussing. When Neruda's body was finally returned to Chile after its many years of exile, Fernanda went to the burial at Isla Negra. This bent, aged woman cursed the *carabiñeros*, Pinochet's fascist police, when they stopped her at the border, asking her why she had come to see this traitor's grave. "Because you haven't killed me yet, you stupid sons-of-bitches," she replied.

I had come to Argentina to find the bones, to see the irrefutable proof of death. In the process, I found Fernanda, the only person I'd met whom I was sure would never harm a child, who would always risk her own life to save another. No excuses. No pretense. I didn't know whether I should be filled with joy because I found her or inconsolable because she was the only one.

Chapter Fifteen

Ramón Screams

The screams woke me up in the cold, dark room. Ramón's terrified voice rose directly from underneath my bed—"No, no, no." In my sleepiness, I shouted down to him in the bunk below, the first thing I could think of—"*Soy yo*, Ramón. . . . *Soy* Eric. *Soy yo. Soy yo. Está bien. Está bien. Soy yo.*" It's me, Ramón. It's Eric. It's okay. It's okay. I'm here. At the sound of my voice, Ramón settled down and fell back to sleep, his mumblings at the distant nightmare softer now.

I looked at the dim light coming through the window above my bed, saw my breath crystallize in a cone of cold. I thought of the reasons Ramón might have for screaming in his sleep, and I wondered at my own.

It was the mid-1990s, and I was in Peru. Again, I was on summer vacation, this time from my Masters at Columbia University, although it didn't feel like summer in that wickedly cold room. Like those nights in the Argentine monastery years before, I wore all my clothes in bed—my hat, gloves, a shirt wrapped around my mouth—trying to conserve as much body heat as possible. Ramón was my boss at a human rights organization I was working with. We were spending the night in some forgotten village in the highlands of Cuzco on a human rights observer mission.

Earlier that day, Ramón, I, and the rest of the team, had almost been killed in a car crash. As we came up the winding, mountain road, a mini-bus passed our pick-up. For a few moments, it was neck and neck with an armored car ahead of us. Right beyond the corner, out of sight of all three vehicles, a peasant woman was dragging her cow by a rope across the road.

The bus narrowly missed the *campesina* and struck the cow in the head, twisting its neck around. Blood sprayed into the air. Brake lights broke. Brakes screeched. The armored car smashed into a tree stump, preventing it, just barely, from crashing into the fenceless chasm below. Our driver pumped the brakes and stopped us just before the bumper of the armored car.

Giddy, I looked down into the rocky gulch, thinking how far away medical attention was. Turning to see Ramón's face, twisted and pale, I became terribly thankful to be alive. I looked across the road and saw the peasant woman who had almost caused our deaths, who had just missed being killed herself by half a meter. Amidst the shouting and

recriminations of the various drivers, she fiercely slapped the wounded—although surprisingly still alive—cow with her open palm, swearing at it, blaming it. The animal screamed under the hot sun, legs buckling, huge torso swaying, dripping blood. I suddenly felt sick.

Later that night, we stayed in a dormitory of a local church. Our team members passed around the bottle of grain alcohol, slowly getting drunk, trying to erase the memory. One of them remarked, "Those peasants are worse than dogs on the mountain roads."

The "peasant problem" was a common topic of conversation during my stay in Peru. Many so-called experts (mostly foreign anthropologists with a romantic vision of the jungles of South America) had labeled the awful war between *Sendero Luminoso* (Shining Path) guerrillas and the Peruvian Armed Forces as a "peasant revolt".

It was true that both sides in the conflict were genuinely concerned about the peasants. Both were concerned about how to control them, how to manipulate them to achieve their goals, how to slaughter them if they got in their way. Abimael Guzmán, maniacal founder and leader of *Sendero*, proposed an all-out class war. His plan was for the peasants to rise up against their bourgeois oppressors and to establish an agrarian utopia along the lines of Pol Pot's Cambodia. To achieve this, Guzmán was prepared to pay what he called "*la cuota de sangre*", which might entail a bloody sacrifice of up to a million lives.

For his part, Alberto Fujimori, the pseudo-democratic president of Peru, had a plan of his own. Descendant of Japanese immigrants, he publicly identified himself with *los indios*, *los negros* and other oppressed racial classes. He promised that, once the rebels were crushed, he would provide economic prosperity for everyone, of every race and color. However, for all his talk of the disenfranchised, Fujimori viewed the peasants as an ignorant, unruly lot, against whom he unleashed one of the hemisphere's bloodiest counter-insurgency campaigns.

The order of events would normally go something like this. The terrorists—generally bourgeois in origin and unappreciative of the needs (or vulnerability) of "the people" for whom they were waging class warfare—would occupy a village. They would force some men and women to join them, steal food and supplies, and then they would depart. The Peruvian Armed Forces would arrive soon thereafter. In reprisal for the villagers having "aided" the terrorists, they would murder some local leaders, rape some women and/or men and steal their cattle. Later, the terrorists would return and punish the remaining villagers for having "collaborated" with the government. Then followed a typical spate of beheadings, rapes, burnings. . . , etc.

In terms of sheer barbarity, *Sendero Luminoso* was the worst of the two groups. (However, I'm not sure the villagers whose children were murdered in front of them by Fujimori's soldiers made this distinction.) *Sendero Luminoso* also had less political legitimacy than the government,

mainly because the movement wanted to reestablish Peru along the lines of the Khmer Rouge's horrifying "agrarian utopia". Nonetheless, Fujimori undercut this strained legitimacy by perfunctorily dissolving the Peruvian Congress one day and having his men tie a rope around it, like an out-of-service restroom. Then there was the anti-terrorist law.

I and the rest of the observer mission were gathering testimonies from prisoners arrested under the government's new anti-terrorist law. In a shining example of Latin American jurisprudence, accused terrorists were given leniency if they named other terrorists. As one can well imagine, the terrorists *did* come up with a list of names—ex-girlfriends, women who wouldn't suck on the first date, former bosses who'd yelled at them for punching in late, brothers-in-law who owed them money. . . , etc.

Many innocent people named by the terrorists were arrested, held for weeks incommunicado, tortured, and made to confess to non-existent crimes. They were tried by *"jueces sin rostro"*—faceless judges—whose heads were bagged like Grand Dragons of the Ku Klux Klan, and whose courts offered them minimal and ineffective defense. (This arrangement is eerily similar to what's now being proposed in England to deal with Islamic terrorists.) At the time, a contact of mine at the U.S. embassy in Lima told me it took an average of two years—after the appeals and the bribes and the bureaucracy –for an *innocent* person to be released. That is, if this man or woman wasn't killed beforehand by his or her fellow prisoners or guards.

In the cold, dark room, I understood the fear Ramón felt. Ever since I was about eight or nine years old, I've had what are called the "night screamers". Now I only vaguely recall having them, but my parents remember how they'd hear me screaming late at night, as if someone were flailing me with a scalding knife. They'd run into my room to see what was wrong, and find me, back against the wall, rigid, eyes filled with terror, breathless. This went on for years, my parents finding me in the same position, gasping from the screams.

Although I haven't had the screams for years, I vividly remember the dream that caused them. I'm in a dark, cavernous room, sitting in a very, very tall, high-backed chair of cartoonish proportions. (It reaches all the way up to the ceiling.) A door opens behind me, a very tall door, and the light from another room spreads slowly over my chair. "Its" shadow advances across the floor, creeping. I never see the monster's face. All I see is the shape of it, approaching, framed like a dark oil painting by the borders of the perversely-skewed armrests.

It was in that very tall chair that my parents would find me, screaming, paralyzed against the wall. I've often wondered what that dream meant. Was it fear of the dark or the Stranger coming to take me away? As I looked through the curtainless window down into the empty parking lot of the church, it hardly seemed to matter. I'd seen so much since then.

Ramón groaned once more in his sleep, and I whispered down to him, "*Soy yo, soy yo, soy yo.*"

Chapter Sixteen

Belief System

I looked out at the cloud-shrouded mountains through the airplane window, and I thought of the promise I was breaking to my wife.

Only a few weeks before, Luján and I had been married in the chapel of her home town, just outside of Buenos Aires. (We'd met when I was writing my Fulbright dissertation there.) She was—*is*—the love of my life. More important than any research, book or fact-finding mission. We'd only been dating a few months before I had to return to the U.S. We then spent most of a year apart, while she finished up her bachelors in Buenos Aires and I started my masters in New York. I was the stereotypically poor graduate student. I didn't even have enough money to travel down to Argentina for my own wedding, so I won a scholarship to work for the summer in Peru; by this means, I saved enough to pay for the leg between Lima and Buenos Aires.

The wedding was beautiful. She wore her mother's wedding dress, held a simple bunch of white roses as a bouquet, and tied a red ribbon to her wrist for good luck. I wore the only suit I had—double-breasted, black—a graduation present from my parents. Luján bought me a ten-dollar tie. We spent a two-day honeymoon in Argentina, and then I left her for Peru.

Leaving Luján was the hardest thing I'd ever done. My mother had taught me, at the heart of every mystery novel is the maxim, "*Cherchez la femme*". ("Find the woman.") Well, I'd finally found her, the woman I loved, who loved me, who soothed my nightmares and gave me hope. And then I left her.

And leaving Luján for Lima wasn't like leaving her for Vienna or Paris or Budapest. Any one of those cities still would have meant isolation, but it would have been more bearable. I'd left her for Lima, city of pain and misery, city of poverty and delinquency. With razor-wired electric fences topped off by broken bottles held fast in mortar. With brown-shirted men with shotguns guarding the houses of the rich. Rife with terrorism and the blossoming cult of militarism.

And then, my broken promise. I'd promised her before I left that I'd never go to the province of Ayacucho, perhaps the most dangerous place an American could go in all of Peru. But then I was invited to attend a conference there on peasants displaced by the recent war—the subject of my research paper at Columbia—and so, off I flew, regretting what I was doing, thinking myself the most stupid man in the world.

The Pear Tree: Is Torture Ever Justified? / Eric Stener Carlson

When I landed at the airport, it was a novelty for the soldiers to check my passport. Amongst the steady flow of dark-haired, dark-skinned, obviously-Peruvian highlanders no more than five feet tall, they stopped me—six foot two, blue-eyed, Nordic, painfully American and out of place. They gave me a strange look as they asked, "*Por qué está aquí?*", and an even stranger one when I answered, "*Turismo*". You're here for tourism? In San Cristobal de Huamanga, Ayacucho, cradle of terrorism, birthplace of *Sendero Luminoso*, sworn enemy of Yankee imperialism? "Yeah, good luck, you stupid s.o.b.", their eyes seemed to say.

I felt like such a fool. Ayacucho—the word conjures up images of burning cars and bombed-out buildings, in places like Sarajevo or Beirut. Not only was I the only non-Peruvian there, but also, as far as I could tell, I was the only non-*ayacuchano*. With my light skin, towering height and strangely-blended Argentine/mid-west accent, I was a walking request for a terrorist attack. Looking back, I remind myself of a certain Spanish reporter I'd heard about on assignment to Bosnia. He wore a red bulls-eye on his T-shirt as a joke. (I've often wondered how long it took for the Serb snipers to deliver him the punch-line.)

San Cristobal was a wasteland. The city was bereft of any charm, except for the public square with its peeling verandas and withered shrubs. Although there were still rumors *Sendero* was active here and there, people kept telling me, "Oh, don't worry. Things are fine now. You should have seen it two years ago." Indeed, I was very sure that had I been so unfortunate as to have been in Peru two years earlier, I would definitely, *definitely* not have wanted to have seen San Cristobal. Except, perhaps, from far away on television.

As it stood, "two years after", now that Abimael Guzmán was in jail (thanks to methodical police work), now that the terrorists—and many innocent bystanders—had been wiped out (thanks to military bloodlust), San Cristobal was a desolate, despondent place. It was like a back lot for some spaghetti western: the anonymous abandoned town, adobe walls, iron grillwork sticking out of its roofs. And yet, somehow, it was populated.

Most of the inhabitants of Ayacucho were "the peasants" that everyone kept talking about. If the dilettante terrorists of Guzmán and the professional terrorists of Fujimori had specific ideas about how they were going to deal with the "peasant threat", the peasants also had a very clear idea of what they'd do to people who threatened them.

There is a deep-rooted mythology that grows beneath the dusty streets of Ayacucho. It is dark and dangerous. And it is very real.

On the single occasion I ventured out at night from the cement hut I was staying in, (trying to find a *kiosko* that was open, so I could buy some toilet paper), I had the very clear impression I did not fit in. Dark looks from the shadows. Wandering eyes. I thought to myself,

"You stupid, stupid, asshole, they'll put 'Died in the heroic act of buying toilet paper' on your tombstone." During the day, there was much joking by the squat, rotund, indigenous women who'd stop me on the street. They offered to have sex with me "*para mejorar la raza*"—to improve their race. I told them, "No thanks, I'm married." They replied, laughing, "So are we."

But for all the jokes, for all the admiration the *ayacuchanas* professed for my light skin and my blue eyes, I was also a symbol of neo-colonialism, imperialism, a threat to their way of life. I was, in short, a *pistaco*.

The *pistaco* is a vampire-like creature that murders small children by sucking, not the blood, but the fat out of them. In other words, the *pistaco* is the Andean version of the Stranger. He's the one parents from Ayacucho warn their children about, the man who follows them home from school, who hides in the bushes. He's the boogeyman who murders you, if you don't eat your vegetables.

It's an old myth, and it's gone through quite an evolution over the years. It was once the *conquistador* or the wealthy *mestizo*, anyone who symbolized the invader, the landlord, the aggressor. In the 1990s, the *pistaco* came to be the *gringo*—the CIA or DEA agents who, it was rumored, infiltrated the country pretending to be tourists. According to this urban legend, they used their cover to hunt down little children and cut their organs out (without anesthetic, of course) for illegal transplants in dens of evil like New York City.

A few years before, the good people of San Cristobal had found a *pistaco* right near the very spot I was staying. Of course, it turns out he wasn't a *gringo* at all but a light-skinned—and very drunk—*limeño*. As the story goes, one night this tourist from Lima stopped a young girl in the street to either ask for directions or to solicit sexual favors. My Peruvian friends who recounted the story couldn't say which.

The girl cried out. A mob suddenly gathered—like they do in old movies— screaming "*pistaco*". To them, the "*gringo's*" motives were clear. This fellow-Peruvian tried to explain himself, but, in his drunken stupor, no one could understand his "English". The crowd formed a *juicio popular* to determine his guilt. Luckily for him, the elders of the jury found him innocent and ordered him to be released. Unluckily for him, a faction of the crowd, incensed that this "foreigner" was going to get away with the crime of attempted fat guzzling, bludgeoned him to death with ax handles and stones.

Every single day I spent in Ayacucho, I was, in an unpoetic and horrified way, afraid. I stayed far away from children. As I scurried down the street, I laughed and nodded as the women propositioned me. I took off my gold wedding band and tied it around the chain of my cross, so as not to attract too much attention, jealousy, crime.

I lived with the dark fear that, at any moment, the way I looked, my gestures, my accent, my smile could be perceived as a threat, and

the mob would gather to judge me in the street. I hid the love for my new wife and my dedication to Christ, buttoned them both under my shirt. I was the Stranger without rights, the monster who deserved nothing more than a quick death. And perhaps not even that.

Chapter Seventeen

Hemingway's Shotgun

I did survive Ayacucho. That being said, I barely escaped assault from a drunken, old man in the street one day, a two-day beard bristling on his cheeks. Out of nowhere, he accused me of "abusing" his country. Thankfully, a Peruvian friend I was with defended me, quickly rolling up his sleeves, and threatening to beat the man senseless if he touched me. Soon the old man snapped out of it, shook hands with me apologetically and retreated. His hollow, blood-shot eyes followed me as I walked away, and I felt in my pockets for my nonexistent switchblades. (What would I have done with them?)

Soon after, I flew back to Lima, that exhaust-filled waiting room of hell, "that old whore," as Hemingway called death. I had only a few weeks left in my Andean purgatory before I could return to Luján, and the thought of spending them in Lima was devouring me. So I accepted an offer to stay with friends of Ramón who lived on the coast. I'd finish my research on displaced people there.

It was a long, dusty bus ride out of Lima, past the hills pocked with shanty towns, to the Pacific Ocean and its impenetrable, jagged coast. As I approached the outskirts of the village where I'd be staying, I wrote in my diary, the lines jumping and wobbling:

> I don't think that it'd be much of an exaggeration to say that I'm in the middle of nowhere. Except that I'm afraid I'm in the middle of somewhere and that somewhere is horrible. On our way . . . we have passed through some of the most desolate land I have *ever* seen in my *entire* life!

This certainly was a change from the mountains of Ayacucho. The whole land on the coast was desolate, meaningless. All the permanence there was in the shifting sand were a few huts made out of mud and pebbles, sticks with tatters of clothes flapping, drying in the wind.

For four days, I shared an adobe house on the edge of the dunes with a French priest named Jean-Baptiste. He attended to the needs of the inhabitants of what the Peruvians called the "human settlement" of El Señor del Mar (The Lord of the Sea). It was named for a statue of a crucified Christ that washed ashore from a shipwreck in the 17th century,

a "miracle". Most of the people living there had escaped from my late, unlamented Ayacucho. The settlement and its people were much like the icon for which it was named, survivors of brutality, persecuted by the military. Crucified, barely rising above the suffocating sand.

The only land available to them—and it really wasn't land at all—was the ever-changing sand dunes. As I wrote in my diary:

> Just imagine yourself in the middle of the sand dunes—just sand, like Lawrence of Arabia sand. But out of nothing, these people built houses out of adobe, tin—there's hardly any wood—and at least the first of the five waves of immigration since about [the early 80s] has electricity and they have set up a water center as well.

The priest had been with these displaced people from nearly the beginning of their flight, raising money for the children's medicine, providing small loans to fund a bakery and a mechanics shop. Despite its poverty, the village was no El Roble. The people, themselves, had built these houses with pride and pain. They'd carried in gravel on their backs to make roads. They'd made their own water filtration plant, and it worked.

The priest tended to a church that served many of the disjointed, displaced communities in the area. Jean-Baptiste took me to his parish surrounded by four tall brick walls. The reed and mud huts of the surrounding settlement had been wiped away just a few months before by flash floods. Amongst their ruins, he was the only force bringing food, education, hope, and I could see the admiration reflected in the eyes of many people there.

But Jean-Baptiste was not loved by everyone. He had, in fact, been targeted for assassination by *Sendero*. This was because, besides bringing "the destructive slavery of the Church of Rome", he was actually making moves—as minimal as they were—to improve their lives without violence, without recourse to the Party.

Jean-Baptiste wasn't proselytizing in the grand tradition. He wasn't drugging the masses to accept some bullshit theocracy. The kind of god he brought the people in the dunes was a faded, driftwood version of Jesus Christ like the one that had floated there. There was no time to teach the finer points of how God was the Three-in-One, to debate the transmogrification of communion wine, or to analyze what a "virgin" birth really meant. Jean-Baptiste was struggling to hold together the last shreds of a community, while he watched it, every day, fall apart just a little more. His priority was to help the villagers survive in this physical world, today. So he let them mix their own pre-conquest gods with the saints, settled for superimposing Catholic beliefs onto a pagan base.

I don't think I had ever met a more dedicated humanist dressed as a priest before. I wished my friend Fernanda could have met Jean-Baptiste. If anyone could, he'd have converted her. No, on second thought, he would have joined her.

But so many barriers blocked his way. Just attending to the day-to-day needs of the community was almost insurmountable, and there were no gains that couldn't be taken away easily.

Sendero had penetrated el Señor del Mar only two years before. The faded hammer and sickle painted red on the water tank was a haunting reminder of that. But "the unthinking peasants" had kicked the terrorists out. The villagers had had too much of violence back in Ayacucho, and they wanted neither the class war of the terrorists nor the "protection" of the police. In fact, what impressed me most was that the community had no police force—a conscious decision on their part.

In the outlying zones there were, technically speaking, "police", but I can hardly call them that. During the official workday, they took bribes and extorted payments. At night, they committed further crimes, only this time out of uniform—assaulting cars, murdering people for their pocket change. They even went so far as to break into the parish one evening. One of Jean-Baptiste's catechism students heard the police climbing over the walls, so he ran to the public announcement system in the church office and shouted into the microphone, "Come. Come, quickly, everyone. They're robbing us. Come." That night, this act of bravery worked. The boy had scared away the terrorist police.

But, on other nights, the parish's defenders were not as fortunate. Shortly before my arrival, the police had broken into the parish, prickling with their official firearms. They took absolutely everything they could fit into their pick-up truck: medicine Jean-Baptiste had collected for the children, the parish's computer, cash. Then later, *that same night*, they came back for another load, and this time, they took all the parish's furniture. Jean-Baptiste could do nothing but look on with tears in his eyes.

One day, on one of his many trips around the slums, attending to the sick, discussing birth control, Jean-Baptiste saw the men who had broken into his parish selling the church's furniture on the street corner. He said to one of them, "*Señor*, that's the church's chair, the church's table." The man responded, "Get out of here you dirty, fucking terrorist. I know where you live."

There was no rule of law in the sand dunes. No protection. The world was a farce in which all good people suffered.

I spent one of my last afternoons there with the little children in a nearby slum. They lived in even worse conditions than the people in the sand dunes. While Jean-Baptiste talked to some of the parents about attending catechism classes, I took photographs of the reed huts, the piles of bricks that once were walls, now stacked up after the flood, so they could be made into walls again.

A group of children slowly gathered around me, small, gaunt faces, but surprisingly clean. Girls with their one good dress on, boys with their hair combed back and parted down the middle, set against what must have looked like the battlefield of the Somme in WWI just after they'd dragged the bodies off. They asked me to take photographs, posed for me, encircled me, laughing, asking me where I was from.

Out of the sea of children, I was drawn to one in particular, a girl with a small, dirty face, tufts of brown hair, and dusty overalls with a small teddy bear patch sewn to the center of the bib. She couldn't speak. She merely grunted. She was very rough, as she played with the other children. She seemed retarded or mentally-impaired in some way. Several times, she hit me on the leg as hard as she could, and I held her back at arms' length. But then, shyly, she came closer, and, as I bent down to talk to the other children, she touched my face ever so gently.

She was fascinated by my smooth, white skin. She grabbed onto my arm, less aggressive now, love-filled, and I held onto her, and it felt good. In the midst of all the rubble from the flood, and the crime and the poverty, I wanted to assure this one life. I wanted to protect this girl. I wanted to hold onto her forever, take her out of the desert, take her some place safe where she would always be loved.

But the dial on my camera said "36", and the film advance lever wouldn't move anymore. Jean-Baptiste had finished with the adults, and I had to shake the little girl loose—as gently as I could—from where she had wrapped herself around my leg. I returned to the church, waving goodbye to the crowd of little children.

Back in the plaza of the church compound, between the four brick walls the police frequently violated, I waited while Jean-Baptiste prepared for the mass inside. There were a few dry, twisted palms in the middle of the plaza. Half-consciously, I began stripping a long, thin piece from one of the leaves. Then, as I'd done for years as a child on Good Friday, I folded the strip in two, careful that it wouldn't snap, and bent it into the shape of a cross.

At that moment, I felt the most impotent I'd ever been in my entire life, and my impotence was accompanied by rage. I tried to think about God's justice, but the Easter resurrection seemed so far away. I wasn't sure what the word "justice" meant in a place like this.

Yes, we'd all be free after Judgment Day. In heaven, we'd never know pain again, but did that mean we had to sit still and take all this crap until then? Did it mean that Jean-Baptiste had to keep watching the church being defiled by the police, did it mean the parishioners had to be robbed of the most miserable goods they had collected—two chairs, and one table that meant everything to them?

At any moment, men clad in black could scale the walls. They could burn down the church. They could rip off the priest's clothing, fuck him up the ass, slit his throat. They could do the very same to me, and

there'd be no retribution. No inquiries from the government. Social justice was so distant as to be a permanent impossibility. Even if the word got out, beyond the desert and the filth, what good would a report from Human Rights Watch do for me, for any of us, raped and dead, rotting in the sand?

I thought of those pot-bellied policemen with their slicked-back hair, laughing Rinaldi's laugh. Lips pulling back from tobacco-stained teeth, like all the old drunks who'd ever accosted me in fear-filled streets. I thought back to Hemingway's short story, "The Doctor and the Doctor's Wife", after Nick Adams' father and Dick Boulton got into a row. The father was enraged, as he sat down on his bed, filling the chamber of his shotgun with shells, thinking of killing Dick. In the end, he just ejected them onto his sheets and did nothing.

As I heard the sounds of the choir warming up, I longed to have Hemingway's shotgun in my hands, something—anything—that killed or hurt, anything with a sharp edge or a point. A poker. A heavy stick. My red and black switchblades! (Where were they now?) How I'd stab them into the first man—policeman, terrorist or common thief—who dared breach the walls of the church that night.

I thought of the wild, little girl in the overalls I'd met that day—my girl—as I stood in the square, trembling with rage. What if she were the one who needed the medicine the police had stolen? What if she were dying? At that moment, I decided, yes, I could kill those fucking bastards. I could kill "them", those figures dimly outlined in my mind, the vague, dark forces surrounding me.

But what if it weren't a choice of kill or be killed? What if I had one of those mother-fuckers tied to a chair, and he knew where the medicine was? I'd ask him forcefully, that's for damn sure. And if he didn't respond, I'd slap him. And maybe I'd punch him in the face and maybe I wouldn't care if I broke his nose. Yeah, that'd stop his smiling then, that smug son-of-a-bitch. And if I had an electric prod? And if he still wouldn't talk?

How far would I go to save the child? I hated the policemen so much, I was already prepared to kill them. And if the cop didn't know where the medicine was, then he must have been guilty of something else. He was a pig, and probably a murderer, too. Or how else did he become a "policeman" in this corner of hell? And better that one of them paid for once in his life. Right? Right?

Jean-Baptiste came out of the church, his long white robe outlined from the light inside. In the glare, I couldn't make out his face, but saw his arms rising from his sides, ushering me in. The choir lined up, composed of young children and teenagers.

A drum. A wooden flute. An old guitar.

At the head of the line, a child held the painted saint's box. It was closed now, but Jean-Baptiste would soon open it for the celebration. I held the cross as tightly as I could in the palm of my hand, trying not to break it, and I followed him inside.

Chapter Eighteen

Lunch Among Equals

I sat in the wicker chair at a table covered by a small, pink cloth. The waiter came with my order, a bit annoyed with me because I had only asked for French onion soup for lunch. I looked up from my book and thanked him in German. While my head was up, I glanced around the room at the many dark oil paintings of famous—I supposed—and nameless—at least to me— Croatian writers.

It was a chilly December day in the late 1990s. I had sought refuge from the cold streets of Zagreb in the Croatian Writers Club (Klub Knjizevnika). I was there on mission with the International Criminal Tribunal for the Former Yugoslavia, collecting information from medical experts. Now, while the rest of my team was interviewing rape victims and following up other leads, I shared a few silent moments with Somerset Maugham.

Having first been drawn to him by *The Razor's Edge*, I was now slowly, achingly approaching the end of *Cakes and Ale*. I was trying to stretch out the last few words, like the last days of summer vacation back in Ohio before the grueling football camp began. At that moment, Maugham was promising me that a writer was the luckiest sort of man, because all he had to do to cut himself loose from the pain and suffering of the world, from his haunting memories, was to write it all down.

In that warm room, seated among painted strangers, ridiculous tableclothes, I trembled as I finished the book. Maugham was confirming, justifying, all my scribblings on scraps of paper all around the world. The manuscript for the book you're now reading would make me what I most desired to be—free, free from nightmares, free from disappearances and torture.

The answer was so simple! Just write it all down. On the edge of my new covenant with Maugham, I drank my soup. The thick cap of cheese was wonderful. The croutons were fresh and crunchy underneath. The radiator by my left elbow filled me with warmth. Far away, almost out of sight, the monastery and the graveyard, and all the islands I'd ever lived on, burned away like mist on a warm morning that catches you by surprise.

I looked down at Ban Josip Jelacic plaza, past the statue of the frozen man on the frozen horse, to a happy microcosm of former Yugoslav life. A tender Christmas square unfolded below me. Freshly-cut pine trees, red ribbons tied around lampposts. It was like a Norman Rockwell

painting but without the weak chins and goofy smiles. Young lovers (no, more innocent than that—young *girlfriends* and *boyfriends*) jumped off the trams, as soon as the automatic doors sprung open, to embrace amid the falling snow. A time when holding hands sent a thousand tingles up your arms, an end unto itself, not a hurried preface to something more.

Street performers acted here and there. Guitar-players. Groups of adolescents sang "I can't get no satisfaction". Old men sold soft pretzels. It was like some yesteryear in small-town America before Vietnam.

On the edge of the square, one group in particular was drawing a large part of the crowd. It was a small band of Bolivian singers. Red and black embroidered ponchos, pan pipes, a cow skin drum. The crowd engulfed them.

I can't quite describe the fascination with which they held the crowd, hypnotizing them. To me, this was mundane. I'd passed them, crossing the plaza to get to the club, and I'd made a brief, mental note that they weren't very good. I'd seen similar groups all around the world, in New York, Berlin, Buenos Aires. They were clichéd and needed to practice more.

But to this crowd, they were mystic, powerful. The children, wide-eyed, clapped to the wandering, indigenous beat. Parents laughed. And then, inexplicably, my jadedness abated for a moment, and I was caught up in the magic of it, too. The ill-practiced, amateurish tune of "*El Condor Pasa*" that came wheedling out of the crude flute sounded quite beautiful.

But slowly, my cynicism and eye for detail began to cloud over the bright occasion. I noticed the camouflaged uniforms of the demobilized soldiers scattered amongst the crowd. I remembered—how could I have forgotten?—that these people were part of a recent war aimed at exterminating an entire ethnic group. Although, numerically, the Serbs had done the worst by far, Croats had dipped their hands into the pot of barbarity as well. They had killed children, tortured the soldiers they captured.

I thought, as I scanned the mirth-filled crowd, for how long would they find these Bolivians exotic, quaint? A day. A week, perhaps. But what if these musicians moved in next door to them, and what if they wanted to marry their daughters? Dark-skinned, illiterate, third-world, job-stealing peasants.

If you trace their genealogy back far enough, Croats, Muslims and Serbs in the former Yugoslavia come from the same ethnic group. Some even come from the same families. What happened is that, when the Ottoman Empire invaded so many years ago, some of their ancestors adopted Islam, and some did not. The difference between these ethnic groups is —there is almost no difference. It's really just a matter of a black zebra with white stripes versus a white zebra with black.

The Pear Tree: Is Torture Ever Justified? / Eric Stener Carlson

But say that to the supra-nationalists in Croatia, and they're liable to string you up. The people in the square down below me were speaking "Croatian", not Serbo-Croat as it used to be called just a few years before. They resuscitated words from before World War II to distinguish themselves from their Serb and Muslim enemies. They used language as a weapon, like Trujillo did in Dominican Republic. They flew their checkered flag, spread their lies that the battered, ill-armed Muslims would launch a fundamentalist, anti-Croat jihad, if they didn't wipe out the Muslims first.

With all the similarities between these two groups, and they still couldn't get along, what would these happy, fascinated people in the square do to those they were less closely-related to? What would they accept being done in their name to, for example, these dark-skinned Bolivians, if their State declared war against them?

I couldn't erase all the witness statements I'd read, describing Orthodox Serbs and Roman Catholic Croats forced to make the sign of the cross when they were captured by the other side. One way is Orthodox. The other way is Catholic. (I'm not sure if it has to do with the flourish or the spacing of the fingers.) Those who did it "incorrectly" would be urinated on, and have their fingers cut off.

So, that's what it's all about, then? That slight movement across the chest your fingers make is the difference between "us" and "them", a Balkan form of parsley. Isn't it wonderful that Jesus Christ's self-effacing death on the cross not only gave us eternal life but also a simple way of telling our enemies apart, so we can butcher them? Amen and amen.

I realized, looking down on the square, that my dear friend Maugham was not entirely correct. I couldn't be content with just writing it all down. It had been almost twenty years since I left Australia, ten years since Santa María, and that's what I'd been doing all along. I was the camera lens, not the photographer. I was the medium, not the one who makes the artistic choice. To write down the nightmare is only the prologue to freedom. It is the mere whisper of the hope of it.

I sat, warm and safe, in my writer's café, thinking high-minded writer's thoughts. But it was not the clean, well-lighted place I pretended it to be. Although the window and radiator separated me from the cold crowd below, I was still soldered to them, a part of them. Like that laughing child perched upon his father's shoulders, I was caught up in the roar of the engulfing crowd, accepting everything I'd ever been taught or told.

We are all one extended family of torturers. In this, our lineage is undeniably intertwined. Croatians, Dominicans, Australians, Argentines, Americans, Peruvians all.

It's true, no one in my immediate family has ever taken the cattle prod into his own hands, used it on a naked, shivering man. (All of this to save a child.) But there it is, the primordial formula, the possibility in all of us. We need look no further than the television.

Think back to all those B class, Dirty Harry-Schwarzenegger-Stallone action movies you've ever seen. The main character's a representative of the law, a small-town sheriff, a big city cop or FBI agent. Here's the plot tension: he's prevented from putting a mass murderer behind bars, because some stupid technicality of the law protects him. He forgot to read him the last syllable of his *Miranda* rights, or he found the bloody knife through an illegal search and seizure. (And this disgusts us, because this murderer is no average criminal but someone *really* bad, like a multiple nun rapist or a terrorist.)

Our hero's an honest man with a spotless record. Now, however, through the weight of events, he's forced to go *beyond* the law, *above* the law, *through* the law, and all the other prepositions related to violating the law that the Dick-and-Jane scriptwriters in Hollywood can come up with. The law. The law. The law. So much law on late-nite television. So little justice.

In the final scene, our hero confronts the murderer, punches him, karate chops him in the head and ties him to a chair. Then he tortures him in the same way his victims had been tortured. With satisfaction, we see how he grinds up this fiend's feet in a meat-processing machine, or, perhaps, he shocks his testicles with a car battery. But that's not enough. For our thirst for TV vengeance to be slated, the hero must kick the villain through a plate-glass window several stories up. The camera clicks slo'mo' as he falls, and we see him impaled on a meat hook, or better yet, on a church spire. Just before he expires, the criminal is conscious of the pain and the irony of the situation, and our hero hobbles off into the sunset. "It's just a flesh-wound", our hero says to the girlfriend he's just saved, and they embrace.

As the movie ends, the message blinks upon our screen that no animals were injured in the making of this film, and we get up and turn on the lights. Brutality so easily digested, even enjoyed, whether on television or on the battlefield, becomes us.

Am I being melodramatic? Isn't this just light entertainment? After all, I've seen all these movies, too, and they haven't affected my ability to separate reality from fiction. I became an academic and an advocate and a diplomat, so they can't count for much. Then again, I've never had to make the kind of decision Foster made. It's always been made for me. By Foster. By my parents. By my President. And, come to think of it, after watching these movies, and especially after studying these awful methods all these years, wouldn't I be a superb torturer, if ever I tried my hand at it?

I wonder why, of all the perpetrators' files I've ever read, "Rambo" tends to be the favorite nickname. It seems like every other torturer I've investigated was a karate instructor at the local school or military base or YMCA. They copy what they see on movie posters, tying strips of cloth tightly across their foreheads, crisscrossing bandoleers of large-caliber bullets across their chests. Some of them even improvise on the

theme. They make their own maces at home, welding metal balls and concrete nails to lead pipes. They give these weapons nicknames, like "Crusher" and "Raper" and "Ruiner", like so many twisted, imaginary friends.

But they're different from you and me, aren't they? We know how to differentiate harsh images on the screen from harsh actions in real life.

But let me ask you this. When you see some kindergarten child molester on the evening news, have you ever whispered under your breath, "I'd like to cut his nuts off!"? In the morning paper, when you read a serial rapist has plea-bargained his way to a work farm for three months, haven't you ever thought, "I hope he drops the soap in the shower and gets fucked up the ass until he dies!" It seems awful for me to write that, doesn't it, but we all think or say things like that, don't we? Even if it's for a millisecond? But that doesn't mean we really want it to happen, right? It doesn't make us Hitler or Jeffrey Dalmer.

I remember a telephone conversation I had with one of my best friends from college, right after that American teenager was about to be caned for vandalism in Singapore. Out of the empty air, he suggested we bring back public floggings in the United States. That would solve violent crime in America. And he wasn't alone. Thousands of Americans wrote to their representatives, requesting they bring back the whip. (Politicians from Mississippi not only suggested reinstating public whipping but also public hangings as well.) But I don't think my friend really meant it. He was probably just blowing off steam.

There's also a difference between saying ugly things and not saying anything in the face of them, right? I, myself, have held my tongue a time or two during dinner parties in Argentina, because friends of friends of mine have relatives who were torturers during the Dirty War. I've learned to dodge the many bodies, the many soggy tombs as topics of conversation. I've learned to be quiet, to have another stuffed mushroom, another stick of celery with blue cheese and red onion dip. I've told myself, "Hush. Hush. Don't mention the dead." It doesn't mean I'm against human rights. It's just that, after so many long, dragged out confrontations, I've learned when not to make a scene.

I've nodded, understandingly, at official functions, when I've met racist, sexist, condescending men, who think God has put them on this earth to rule every "inferior" class, screw every "bitch", kill every "faggot". I don't use their language. I don't laugh at their revolting jokes. I just maintain a constant, diplomatic smile, thin and taut like a piano wire wrapped around the throat. I take a glass of cold mineral water from the waiter's tray, and we exchange banalities with Ivy League tonalities, wearing our hand-tailored shirts pinned with monogrammed cufflinks. From the outside, there is little difference between them and me.

It's not that I think the world's too fragile, that saying these things, watching these things, accepting these things, suddenly kills off

all our collective sense of goodness, like the way we kill Tinkerbell by proclaiming "I don't believe in fairies". But I do believe something special does die off in each of us, with every harsh word we say or every one we let fall onto the dining room floor and don't sweep up. It hardens us to those who are different from us, makes it easier to hate them, and it'll take more than a hand-clap to bring that quality of goodness back.

What Maugham forgot to say, what any first-year fiction student will tell you, is that the main character must make a fundamental change before the story's over. In *Poetics*, Aristotle writes that the hero must be bad and choose good or be good and choose bad. No one is interested in a mediocre character, one that stays partially saved, partially damned. A mélange of good and evil may be closer to the truth of what we are, but it's not high literature.

As for me, I had yet to make the choice.

Chapter Nineteen

Behind the Curtain

There's one question that troubles human rights advocates, robs us of our sleep: "What if you find the guilty person—the child rapist, the mad bomber— and you torture him, *just once*, to get the information you need?" I'm not talking about torture-as-subjugation or torture-as-humiliation, as it's most often used, but torture for the specific purpose of saving lives. After all, underneath our talk of laws and rights, I'd wager most of us are in favor of brutalizing the minority, if it really promotes the survival of the majority.

For example, if one man *really* has the information to prevent a nuclear bomb from going off, one that would kill a million people, wouldn't it be tempting to torture him? I mean, if we could be sure? I'll put it another, less hypothetical way: if you had an al-Qaeda member tied up in your basement on September 10th, 2001 and you knew *he* knew of some sort of impending terrorist attack involving airplanes the next day—knowing what you know now—what do you think you'd be capable of doing to him?

At the same time, you need to realize there are lots of causes we can convince ourselves are important enough to shred a man's penis with a potato peeler. (No, don't shy away from that image, as disgusting as it is.) Let's say it and see it like it is. "Torture" isn't a code word for things that are slightly uncomfortable, like a paper-cut on your index finger. Torture is cutting off testicles. Torture is raping a woman with a German Shepherd. Torture is my roasting the liver of your twelve-year-old son and force-feeding it to you, until you tell me what I want to know, or until I have completely humiliated you beyond repair.

The "good" reasons for doing all of the above can be saving the Twin Towers in New York or stopping Communism in South-east Asia or punishing the ice cream man because the chocolate coating on your dove bar melted before you could get it home. You see, the problem is, it's often not clear how to tell the *good* reason from the *bad*. Maybe that sounds unbelievable, but if you listen long enough to any one of them—and, believe me, I have—each one starts to sound equally convincing.

But suppose it *were* possible to torture for the "*right*" reasons, to get the terrorist before the bomb goes off, without it escalating, without it harming anyone else. That's why I keep returning to Foster, because, apparently, that's what he did. He *may* have tortured the child rapist, but he didn't violate anyone else's rights. International law didn't crumble.

Vigilantism didn't spread throughout St. Hugh. His actions didn't turn Tasmania into a lawless, military state.

But there's another story I overheard about Foster at the dinner table a few years ago, and that changes things a bit.

One night, Foster was staking out a house, waiting in the hope that a serial rapist would arrive, a man who had raped perhaps as many as thirty women. Foster had set the trap. The scantily-clad policewoman had sauntered down the street, apparently alone, and gone inside the house for everyone to see. Only Foster saw her slipping out.

Then Foster was left all alone in the house, waiting. No walkie-talkie. No police backup. Hours went by, and still he remained alert. Then, suddenly, he started, half-falling from the stool where he had tried to remain vigilant, unblinking. He had fallen asleep, and now he realized, with fear in his heart, he was not alone.

In the quiet room, he felt a presence. Under the window curtain, he could just see the tips of a man's shoes. He could just barely discern the figure of a man against the streetlights. Foster quickly drew his service revolver and fired point blank, emptying the cylinder of its shots at the figure behind the curtain.

He killed the man.

There were no more rapes after that night, at least, none committed in the same modus operandi as the previous ones. Everyone assumed, once again, that Foster had gotten his man. And if the dead man turned out not to be the rapist, then he was up to no good anyway, hiding behind that curtain. Certainly, he was a vicious cat burglar, or a masturbating voyeur at least. *"Por algo será..."*

When I was about seven, after having recently arrived in St. Hugh, I and my brother, Christopher, visited a friend of ours named Simon, who lived up the hill from us. We were having a party at Simon's house. Musical chairs. Pin the tail on the donkey. Find the ring in the pile of flour with your nose, and you will win a prize.

But we were restless boys, easily tired of party games. So we snuck out of the house to go on a Tom Sawyer adventure. There was a fence at the back of Simon's house, and, beyond it, a wide, untamed forest. I don't know if there was a plan to begin with or if it just developed as we went along. I don't know who went over first, but I know I was the last. I was a pudgy child, heavy and awkward, and I scratched my belly on the top of the fence as I went over like some tired, domesticated animal. Simon and Chris ran far ahead of me. I remember running after them, hot and breathless, over the slippery, moss-covered rocks, down and down the emerald slope.

And there, at the bottom, where the ground leveled out, was the reward for our daring—a herd of cows! There were dozens of them, slowly grazing. We scattered, running at the cows, screaming with laughter, wanting to pet them all. I almost sank up to my knees in the cow-trodden

mud. Shouting, running amongst them, slogging a step away from petting them, hearing the "schloop", "schloop" noise as I inserted and extracted my boots. On the edge of my mind, I knew it wasn't right somehow. We must have been on someone's private property. But the cows!

I don't remember exactly what happened next. But the man appeared—I don't remember what he looked like. Thin, I think, and shouting angrily. I learned afterwards, he was the caretaker of the property, a drunk who was paid to keep an eye on the animals. I don't know when he fired his gun at us, but I started running up the hill, and then I fell. I saw the dirt kick up from the shot landing a few inches to my right. How strange that moment was! I saw the dirt and the small rocks move upward, each independent of the other parts, and some sort of weed next to this small puff of dust, a flower. Slow motion, exact, I could count every one of its petals spiraling out from the small, open bud.

And then I picked myself up, and ran and ran. In the back of my mind, I thought of my brother, Christopher, and how I shouldn't be leaving him, how I should go back and look for him, but I kept running and running and running, and I didn't turn back. I must have made it over the fence, although I don't remember how. By the time I reached the house at the top of the hill, I was in shock. I remember little else, except my heaving chest and the face of some absurdly-smiling adult from the birthday party, trying to calm me down. He was ridiculous, I thought, stupidly out of place after what I had just been through. And I was so full of worry for Christopher, thinking he was dead.

And then, some minutes after, Chris appeared, dirty, a foolish smile on his face, limping. He'd lost a boot in the mud. I was overjoyed. He was alive, with a grin on his face that told me everything was okay. And then came Simon, too.

There was a police investigation. They asked what kind of a weapon the man had used. I said, "Shotgun". Chris said, "Rifle". Our testimonies were confused, providing no proof; all the police could do was give the man a reprimand. It seems a group of boys had thrown rocks at his master's sheep a few weeks before, so he was just being careful. A sheep had been killed, so he decided he must kill a boy.

They weren't even going to take the gun away from him, so Foster—again, Foster—went there and impounded it himself. Always intent on saving me.

After all these years of memorizing creeds and codes and covenants, both sacred and profane, one rule comes to mind first when I think of myself struggling up that hill. I learned it in the deep end of the swimming pool when I was twelve: "When attempting to rescue a drowning swimmer, save yourself first." It sounds greedy, perhaps, but of all the lessons, I think it's the only one that will help me tonight.

It means I can't control all the bad things that happen in the world. I can't even begin to think of fixing them, if I don't save myself first.

The Pear Tree: Is Torture Ever Justified? / Eric Stener Carlson

Mass rape in Yugoslavia. Mass murder in Rwanda. Little boys with machetes half their height, ham-stringing mothers and chopping off their hands. There's nothing I can do. I can't bring back the disappeared, the dead. I can only delineate, edit, excavate afterwards.

If some of my family still believes, after all these years, that whatever Foster did, or *could have done*, was right, then I probably won't convince them otherwise, not with this book, not with anything. They are still honorable people who love me, and I love them. And if my best friend talks into the receiver, enumerating the benefits of ripping the skin off a teenager's back, then I can only shake my head along the distance and disagree.

Outside this room, the story continues—the torture, the justification and self-deceit. Foster could live with what he did. Many people do. But I can't any longer. Tonight, in this dark room, where my words are mocked and swallowed up by these piles of witness statements, tales of mutilators who will never see the inside of a courtroom, I pronounce in the presence of this threat of empty chairs that what we authorized Foster to do was wrong, that I would rather die than live like that.

I would rather my society died, if its survival hinged upon my need to torture a child, anyone's child. And we are all someone's child, young or old.

And I will speak out against Videla and Milosevic and Hitler and all the "good" people of the world who advocate torture for all the "noble" reasons or who apologize for those who do. May God help me.

I don't say this now, because I feel "holier than thou", holier than anyone. I have measured the depth of evil inside of me, down and down, on dark nights in dark continents, and still not had enough knotted rope to reach the end. Besides, I'll always be considered "one of them" by someone, one of the many dangerous Strangers to be destroyed. But I'm trying to be a bit more like the man I want to be, the one who says that human rights are universal, who proclaims they're even meant for monsters like Roberts, and also means it in his heart.

But don't be fooled that denouement comes with my epiphany. Even with this decision, I am riddled with neuroses. Some days I leave my apartment and come back three times within the space of a minute, just to check if I've left everything okay. That the oven's really off, that the bolt's really locked.

At night, I grind and grind and grind my teeth. Thoughts of murdered children wear my plastic retainer down. Some days are better than others, yes, and, by midday, I often succeed in convincing myself my wife is not being raped while I eat my steak (well-done) with a side-salad of lettuce, tomatoes and onions. But, clearly, there are days when I do not dare to eat a peach.

As I draw my bars and charts of women raped and children killed, Satan squats in the corner of my room, laughs his subtle laugh.

He's sitting where he's always been, where he'll always be. Because there's still enough of that little boy in me who scurries, horrified, at the thought of the Stranger bringing death, who accepts any solution that the military or police, politicians or parents offer him, no matter how wicked—anything that promises his security.

But having said all that, having felt the fear of enunciating this cold darkness inside of me, there's also an emerging man in me who's more afraid to support an act he cannot reconcile with the love for his family, who sees the contradiction between wanting to protect his wife and son, and willing to torture other wives, other sons, to do so. These are my standards, not my father's or my country's or any tribunal's. Because *The Pear Tree* never was about how *other* people think, how *other* people act, but how do I.

Satan stills sits in this room, that's true. And there are nights when I'm deadly afraid of him, afraid that, with a little push, with a little fear, I could become one of the frothy-mouthed violators I build my cases against. But tonight the devil's the one who's more afraid, of this hard-drive fan hum-humming, of this keyboard click-clicking, of these words slicing white against the blue screen.

Tonight I return to Foster that evening of sleeping easily he gave me so many years ago. Tonight, I peel off, fold, and put back my mother's gloves in the front-hall closet. I kick back the clods of dirt into the empty grave. Because tonight I am old enough, tonight I have seen enough, to have my *own* fears, to create my *own* nightmares that I don't need to borrow them from anybody else. I'm old enough to go back to bed and sleep, knowing there are monsters under my bed when I turn off the light.

Chapter 20

The Pear Tree

It's been almost twenty-five years since I left St. Hugh. (More than three times the span it takes for a pear tree to bloom, or so Foster said.) I've never returned. Perhaps I never will. But I think I know what I'd find if I went back to our house, our garden. The pear tree—that withered stick—has not grown.

On and on, we cut and clip our innocence, our common goodness. We justify any act of torture we want, saying two wrongs make a right. Destroy one life to save another. Rob a man, woman or child of dignity, of bodily integrity. And we may be lucky in what we do. In every single instance we use torture, we may retrieve information that will save many lives. But the victory is fleeting. The reason is twofold. Foster didn't know who was behind the curtain. And Foster didn't care.

I'm sure he thought he was right until the day he died. But each day at the shooting range, he must have realized he'd torn through that thin, origami paper of reasoning which separates the disposable suspect from the protected victim. Every day he shaved, looking at the straight-edge razor, didn't he wonder in the gleam on the blade of it, didn't he hear the playful question, "Why not slit the throat of a child I find on the street today? Why not lure her into my car? No one would suspect me."

Why make the difference between butchering a man I *suspect* of rape and rescuing the rape victim, if the main difference is the importance I attach to one life and not the other? Adopt the logic of your persecutors, and the whole world shifts. The only thing that separated Saul, the mass-murderer, from Paul, the Saint, was a three-days' journey on that lonely road to Damascus. I can only imagine the journey's shorter if you walk back the way you've come. I wonder, how many steps from Damascus does it take for Paul to become Saul again?

I see myself through the rifle sights of the caretaker. A fleeing child, out of breath, struggling up the hill. Unaware, uncaring of anything but my own heartbeat and that short flight to freedom. Through the scope, I am that livestock thief. I am that child molester, that Communist, that radical priest preaching hope in the slums of Peru. We are all that pudgy, frightened child, praying to God we can throw that last, fat leg over the fence and jump, roll, stumble, run home and cry to our mother, before the drunken farmer has time to pull back the bolt and fire again. . . .

Instead of being fired for molesting the female students under his care, Rinaldi has gone from promotion to promotion, becoming one of

the most respected citizens in Santa María. Osvaldo, the man whose name was spray-painted on the village walls, the openly-acknowledged murderer, disappearer of children, won a local election a few years ago. The incumbent had lost face when public employees weren't receiving their paychecks on time. The people wanted "a strong man" to fix things. That's what they got.

In Peru and Dominican Republic, things go on much like they did before. Corruption, disappearances. There are fewer killings we know about, but you never know when it'll start up all over again. If Jean-Baptiste hasn't been killed by now by some policeman or terrorist, it's probably just a matter of time. I haven't heard from him in years, and I wonder how his people in the dunes will survive without him.

As for rebuilding what's left of the former Yugoslavia, and as for our chances of convincing its inhabitants never to engage in ethnic cleansing again, the God's truth is, I don't know. Yes, Milosevic is in jail, and that's a good thing. (While we're on the subject, Saddam Hussein's in jail too.) But has that changed what people who support torture think? Has it changed us?

A few years ago, Foster died of a heart attack. My father was terribly upset by the news, and rightly so, because they had been good friends. By the way, Roberts died, too. He was shiv'ed by fellow-inmates during exercise period one day. It seems, even some of the most violent criminals feel there's something powerfully worse about those who rape and murder a child, and they paid him back for it. When a close friend of the family heard about his death, she called it "poetic justice". Justice. Poetry. Poetry. Justice. I can't find much of either in anything relating to this story.

The bauxite mine, our reason for moving to St. Hugh, closed down years ago. Everyone who didn't transfer off the island in time lost his job. So those dusty, back-roads, concrete villages are more desolate than they were before. But for those who are still alive and still surviving in St. Hugh, there's a feeling that whatever Foster did was right. At the end of the day, he brought the evil man to justice.

But what I've learned in human rights advocacy is that, at the end of the day, there is no end of the day. It's just an empty night that goes on and on, and only some of us can fall asleep under the wide, starless sky. The pear tree stands on the edge of a leafless garden, cold and still, dominant amongst nothingness.

Epilogue

Almost a decade has passed since I began writing the first draft of *The Pear Tree*. At the time, I was on the verge of a collapse, not merely physical or mental, but—and fundamentally—spiritual. My days were filled with doubts about humanity, my nights were filled with doubts about God.

I couldn't get out of my heart, my head, the vision of so many Muslims—good men, good women—tortured by Serbs. While they prayed for deliverance, while they prayed that God would break down, crumble the walls of their torture center, so they could run back to their villages and fields, they were raped again and again and again. And then their children were raped in front of them. I couldn't understand a world that would let the torturers get away with that. I couldn't understand a God who seemed to grant selective miracles—a cancer victim in remission in London, a blind man made to see in Rome—but who left whole death camps in Bosnia unattended.

And then, towards the end of my first year at the Tribunal, my brother, Chris, committed suicide.

After years of struggle against alcohol and drugs, after years of the many voices and paranoia, Chris finally went into the garage, turned on the car, rolled down the windows and slept. And we brothers, who used to be the Three Magicians, suddenly became two.

For the longest time, the only thing for which I prayed to God was that He wouldn't send me any more pain. I couldn't read any more witness statements. I couldn't cry any more for my brother's death. As trite as it sounds, writing the first few pages of this book was my lifeline. Each chapter draft was a prayer when I could no longer pray, each doubt I scribbled down was with the hope there could be a better world.

I sent my manuscript out to several publishers, but there was little interest. For some, the topic just wasn't palatable. (After all, torture doesn't "sell".) For others, merely discussing our susceptibility to torturing was to mention the unmentionable. And so *The Pear Tree* sat in its cardboard box in my study for almost ten years before Clarity Press had the courage to pick it up.

In the personal realm, things have changed since then. With the help of my wife and prayer, my spiritual bones have begun to knit, if not altogether heal. I went back to graduate school and got my doctorate.

I began a career with the United Nations. I became a father.

In the public realm, things have also changed. Perhaps, most importantly, on September 11, 2001, the attack on the Twin Towers in New York City occurred. In response, the citizens of the United States, in their shock and in their outrage, began not only to mention the unmentionable, but also to accept the unacceptable. Like the existence of left-wing guerrillas in Argentina in the 1970s and like ethnic tensions in the former Yugoslavia in the 1990s, the Bin Laden terrorist attack—that real, awful and inexcusable attack—was used as an excuse to roll back our legal prohibitions, and our moral inhibitions, against the use of torture.

Once more, a government—this time that of the United States—is funneling our personal fears into systems and doctrines that support torture. If you believe the current propaganda, the Muslims are now our enemies. No longer the victims of Yugoslavia, they are the terrorists of Afghanistan and Iraq. We fail to register all our prisoners in Guantánamo Bay. Our Attorney General looks for loopholes in the Geneva Convention, and our President paves the road to torture centers like Abu Ghraib with his rhetoric of irredeemable enemies.

That is why I took out the yellowed pages of my manuscript, that's why I resuscitated the words I'd written a decade before. Because torture has become our bread and butter, our morning prayer, our afternoon tea.

According to Amnesty International, U.S. troops are alleged to have used, or been authorized to use, the following interrogation techniques against men, women and children in this "War against Terror":

- Abduction
- Death threats
- Dietary manipulation
- Dogs used to threaten and intimidate
- Dousing in cold water
- Electric shocks, threats of electric shocks
- Excessive and cruel use of shackles and handcuffs, including "short shackling"
- Excessive or humiliating use of strip searches
- Exposure to weather and temperature extremes
- "False flag", ie making a detainee think his interrogators are not US agents
- Forced shaving, ie of head, body or facial hair
- Forcible injections
- Forced physical exercise
- Hooding and blindfolding
- Humiliation, eg forced crawling, forced to make animal noises, etc.

- Immersion in water to induce perception of drowning
- Incommunicado detention
- Induced perception of suffocation or asyphxiation
- Isolation for prolonged periods, eg months or more than a year
- Light deprivation
- Loud music, noise, yelling
- Photography as humiliation
- Physical assault, eg beating, punching, kicking
- Prolonged interrogations, eg 20 hours
- Racial and religious taunts, humiliation
- Religious intolerance, eg disrespect for Koran, religious rituals
- Secret detention
- Sensory deprivation
- Sexual humiliation
- Sexual assault
- Sleep adjustment
- Sleep deprivation
- Stress positions, eg prolonged forced kneeling and standing
- Stripping
- Strobe lighting
- Threats of reprisals against relatives
- Threat of transfer to third country to inspire fear of torture or death
- Threat of transfer to Guantánamo
- Threats of torture or ill-treatment
- Twenty-four hour lighting
- Withdrawal of "comfort items"
- Withholding of medication
- Withholding of food and water
- Withholding of toilet facilities, leading to defecation and urination in clothing[6]

It's awfully tempting to imagine how we could have prevented those deaths on September 11th with one act of torture. But how far iwould that—still unacceptable act—be from the acts we committed at Abu Ghraib and Guantánamo Bay and at all the other places we haven't heard about yet? How far is it from forcing men into cages, stripping them naked, making them masturbate each other? How far is that from jeering at their naked, bloody bodies while they defecate themselves?

This "War against Terror" is much like the French Revolutionary Warfare doctrine of the 1950s and 60s and the U.S. National Security Doctrine of the 1970s and 80s, both of which fortified the Argentine military in its method of mass torture and disappearances. It formalizes, authorizes and legitimizes our most prohibited desires to demean and to degrade, to rape and to defile, all in the name of our children, all in the name of protecting them. And, yet, how many of us would want some soldier from some other country to use any one of those "interrogation" methods listed above on our son—to strip him, sodomize him, make him perform oral sex on his childhood friends and then parade him around on a dog leash to be photographed for his family and all the world to see? Does that make up for the thousands dead in New York? Does it make us feel any safer?

I would like to see my brother, Chris, as I used to see him, sleeping next to me in our fort on starry nights, or the day he cheated death, limping and smirking after we'd been shot at, his boot lost in the mud. I would like to see the Twin Towers before the September 11th attack, shining in the sun, and all the dead risen up and back home with their families. But I cannot, we cannot go back to the way things were. We can only choose whether we use the way things are, *today*, as an excuse to torture "other people's children", or whether we do not.

The conclusion I've come to, after all these dark nights, is the reason we should want so desperately to protect our children, is not because they are *ours*, but because they are *children*. They are innocent. Fragile. Beautiful. They must go on and thrive and succeed where we have failed. This means, "other people's children", from all the categories of Strangers we are so bent on torturing, are worth protecting, too. If we do not learn that lesson, then we are truly lost.

Endnotes

[1] United Nations, *Convention against Torture and Other Cruel, Inhuman or Degrading Treatment or Punishment,* Adopted and opened for signature, ratification and accession by General Assembly resolution 39/46 of 10 December 1984. As appearing on the Office of the High Commissioner for Human Rights webpage, http://www.ohchr.org/english/law/pdf/cat.pdf.

[2] Human Rights Watch. *The Legal Prohibition Against Torture.* © Human Rights Watch June 1, 2004. As appearing on Human Rights Watch webpage, *http://www.hrw.org/press/2001/11/TortureQandA.htm.*

[3] United Nations Department of Public Information, *Universal Declaration of Human Rights.* As appearing on Office of the High Commissioner for Human Rights webpage, http://www.unhchr.ch/udhr/lang/eng.htm.

[4] Mill, John Stuart, *On Liberty* (Harvard Classics, Volume 25, Copyright P.F. Collier & Son, 1909). As prepared by *dell@wiretap.spies.com* and enhanced and converted into HTML by Jon Roland of the Constitution Society, appearing on *http://www.constitution.org/jsm/liberty.txt.* In the public domain, released September 1993.

[5] From "A Clean, Well-Lighted Place." Reprinted with permission of Scribner, an imprint of Simon & Schuster Adult Publishing Group, from THE SHORT STORIES OF ERNEST HEMINGWAY. Copyright 1933 by Charles Scribner's Sons. Copyright renewed © 1961 by Mary Hemingway.

[6] Quoted textually from Amnesty International, "Human rights not hollow words: An appeal to President George W. Bush on the occasion of his re-inauguration", (19 January 2005). As appearing on Amnesty International webpage, *http://web.amnesty.org/library/Index/ENGAMR510122005?open&of=ENG-USA.*